CAMDEN HOUSE

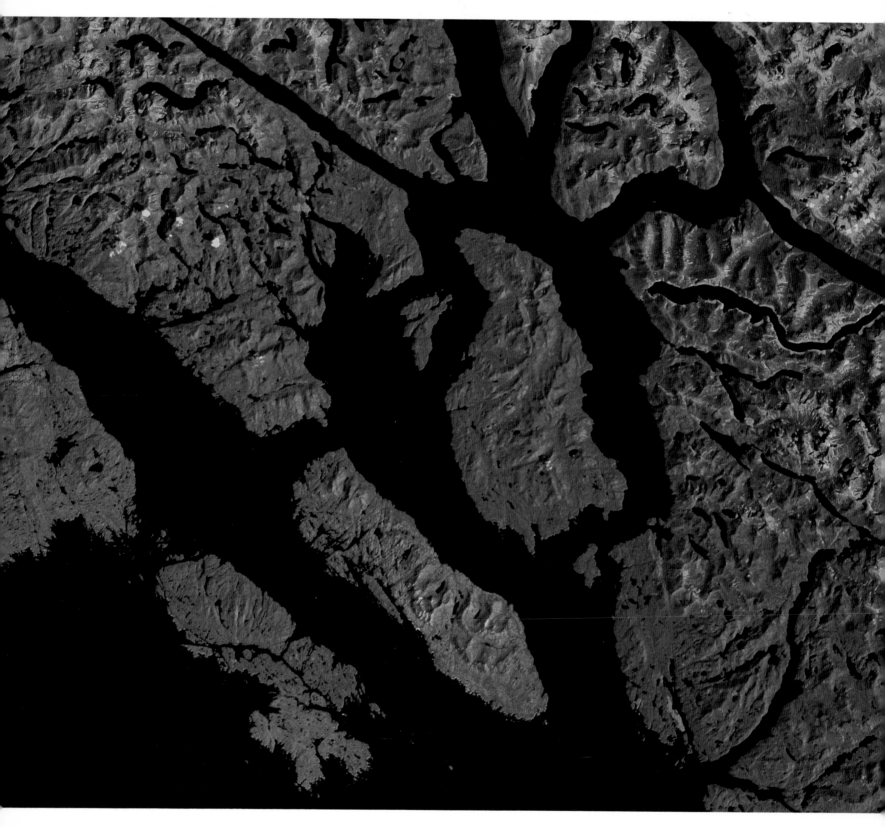

TEXT BY BRIAN BANKS

PHOTOGRAPHS OF CANADA FROM SPACE

CAMDEN
·HOUSE·
♦♦♦♦♦♦
PUBLISHING

Canadian Cataloguing in Publication Data

Banks, Brian
 Satellite images: photographs of Canada from space

ISBN 0-920656-72-2

1. Canada—Photographs from space.
2. Canada—Maps, Topographic.
3. LANDSAT satellites.
I. Title.

FC75.B36 1989 912'.71 C89-094557-8
F1017.B36 1989

Trade distribution by
Firefly Books
250 Sparks Avenue
Willowdale, Ontario
Canada M2H 2S4

Printed in Canada for
Camden House Publishing
(a division of Telemedia Publishing Inc.)
7 Queen Victoria Road
Camden East, Ontario
K0K 1J0

Design by
Linda J. Menyes

Colour separations by
Hadwen Graphics Limited
Ottawa, Ontario

Printed and bound in Canada by
D.W. Friesen & Sons
Altona, Manitoba

Printed on 80 lb. Jenson Gloss

For fbe

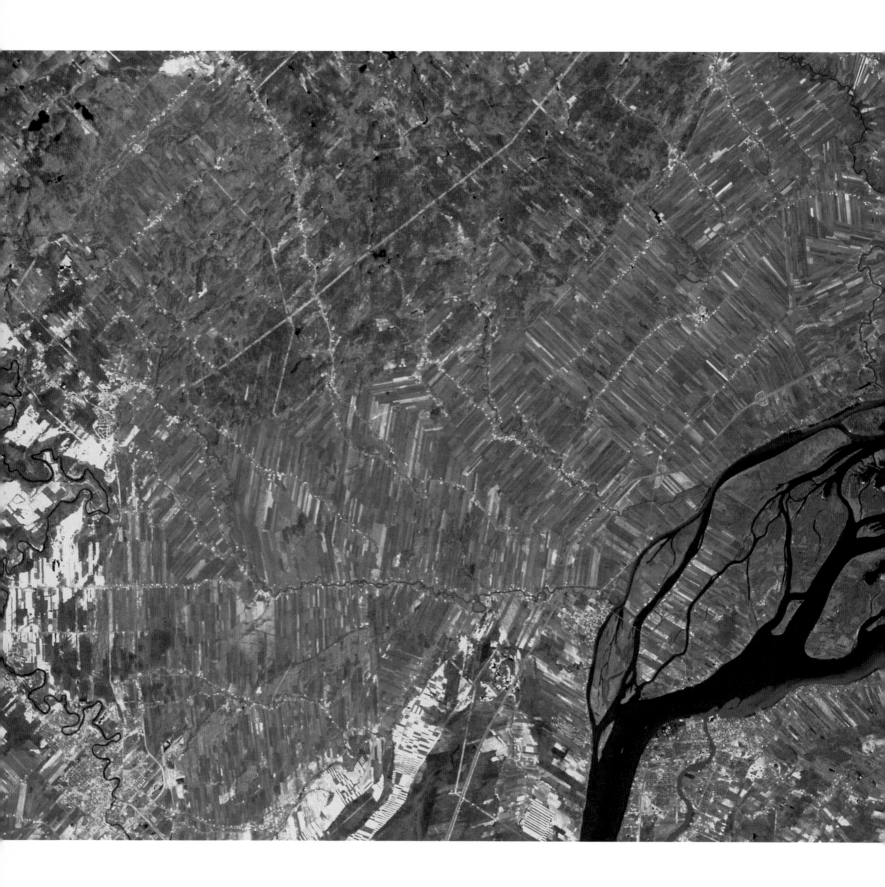

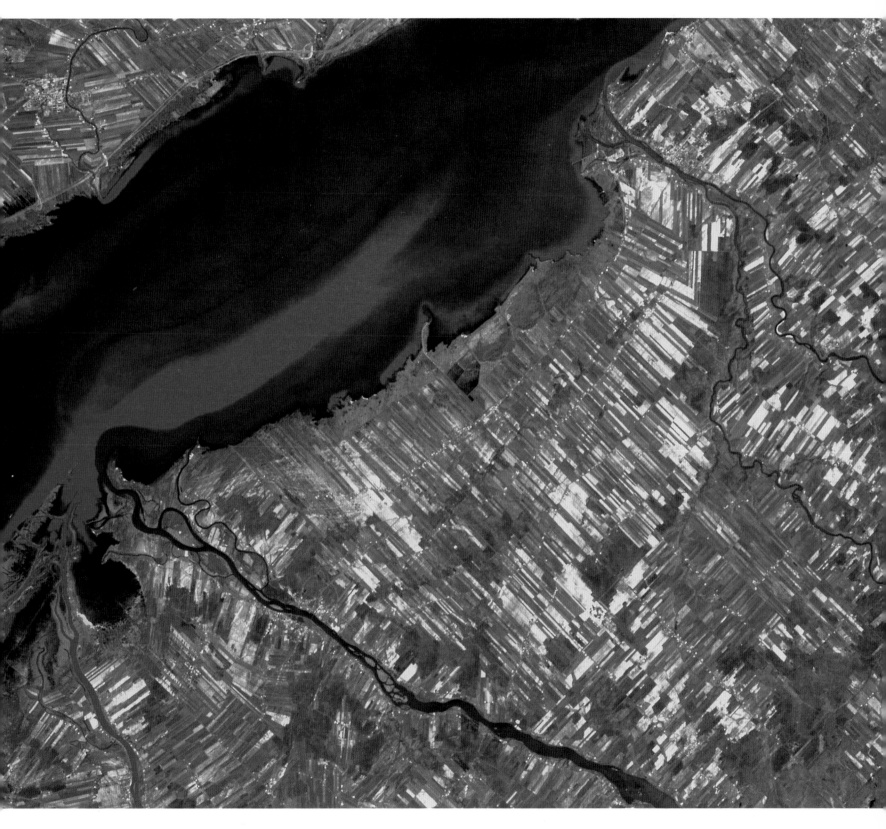

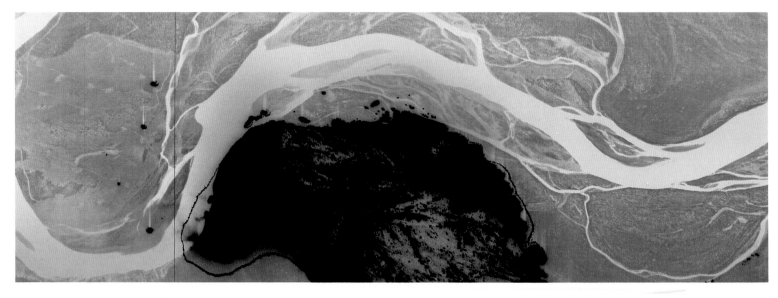

Used to provide tactical information to forest-fire-management teams, the thermal infrared scanner records heat waves emitted from the ground. The scanner, mounted in an aircraft, can receive information through both smoke and darkness, garnering such essential details about a fire as its perimeter, its intensity and its proximity to communities, woodlands and access routes. The image above was acquired at 1,800 metres above ground level over an active forest fire. Right: Advanced Satellite Productions Inc. and MacDonald Dettwiler and Associates Ltd. have produced a series of satellite views of Canada by taking digital information from Landsat and manipulating it with custom-designed software. This scene, which has been given "natural" colour, includes Vancouver, centre; the Gulf Islands, lower left; the Strait of Georgia, left; and the Fraser River.

The twin-engine Merlin III B airplane made its first pass over Murray Macquarrie's trailer and the Ontario Ministry of Natural Resources' Kenora-14 fire-fighting base camp shortly before midnight. In his bunk below, a tired Macquarrie had just closed his eyes, hopeful of a few hours' sleep. Hearing the turboprop's faint drone, he pictured the plane crossing the dark sky over the camp. From there, it would be just a short trip before it reached the near edge of the district's fourteenth fire, an extensive smoky blaze that had already capitalized on steady winds and unusually dry spring conditions to burn a quick 20,000-hectare swath through the northern Ontario forest. The mental image allowed Macquarrie, the fire boss in charge of the entire Kenora-14 fire-fighting operation, to rest a little easier. While he knew that a sudden change in wind direction could still send the fire sweeping down on nearby villages and cottages, the overnight flight ensured that by sunrise, he would have an important new tool in his fire-fighting arsenal: for the first time since arriving on the scene almost a week earlier, he could look forward to starting the day with accurate, up-to-date maps of the fire's advancing perimeter.

Macquarrie would get those maps from the Merlin's crew in time for his regular morning meeting with the "suppression people" at camp. With more than 700 fire fighters and three-quarters of the province's forest-fire-fighting equipment at its disposal, his team welcomed the new information. "With such a large fire and so much smoke, it was impossible to send someone up in a helicopter during the day to locate the fire's edge," Macquarrie later recalls. "Yet it was essential to know where that perimeter of the fire was so we could attack the thing —and attack it in the right place."

Ordinarily, sending a plane up in the middle of the night to map anything, let alone a smoke-enshrouded forest fire, would seem futile. What made the difference in this case, however, was a small metal-and-glass instrument mounted under the Merlin's nose. Known as a thermal infrared scanner, the sensitive electro-mechanical device can pinpoint a fire's location by recording the amount of nonvisible thermal infrared energy (heat waves, basically) being emitted from the ground below. Suspended over a small opening in the plane's outer fuselage, the scanner peers through darkness and smoke with impunity.

Getting the scanner's readings to a fire boss and the fire-management team in a form they can use is made possible by the racks of additional electronic gear cluttering the Merlin's interior cabin. The equipment leaves little room at the rear of the plane, except for an operator's console where,

while in flight, a monitor displays the infra-red image of the fire moments after it is received. Alongside the monitor, another device spits out a continuous narrow strip of photographic film imprinted with the infrared image. Areas on the ground that are relatively cool show up as lighter zones on the black and white film, while progres-sively higher temperatures appear in ever darker shades. From these images, an interpreter on the plane can isolate hot spots marking the fire's advancing front line and can then plot their location on existing topographic maps of the region.

"This technique can be very accurate and very worthwhile," explains Macquarrie. "Our suppression people were able to look at that imagery early in the morning and develop their action plans immediately, without even visiting the site."

Going aloft to obtain a clearer view of things back on Earth has not always been such a dramatic, highly technical pursuit. Yet its powerful and practical appeal has been second nature to humans for as long as there have been hilltops to conquer and trees to climb. There are probably few peo-ple who realize it today, but the develop-ment of hot-air balloons in the 1780s—providing humans with their first truly air-borne perspective—owed as much to the age-old desire to get a better look at the surroundings as it did to the decidedly modern urge to get from point A to point B. Following the invention of photography some 50 years later, people discovered the extra utility that came from bringing the view back with them when they returned to Earth. That union of photography and flight enabled people to see themselves and their world as never before. It also marked the beginning of a new field of exploration and science, now called remote sensing.

Airplanes supplanted balloons as the air-borne observation platform of choice early in this century, carrying ordinary cameras first, then infrared scanners, radar and lasers all tuned to invisible parts of the elec-tromagnetic spectrum. In the past 30 years, spacecraft and satellites have added yet another perspective. Together, observa-tions and measurements from all of these

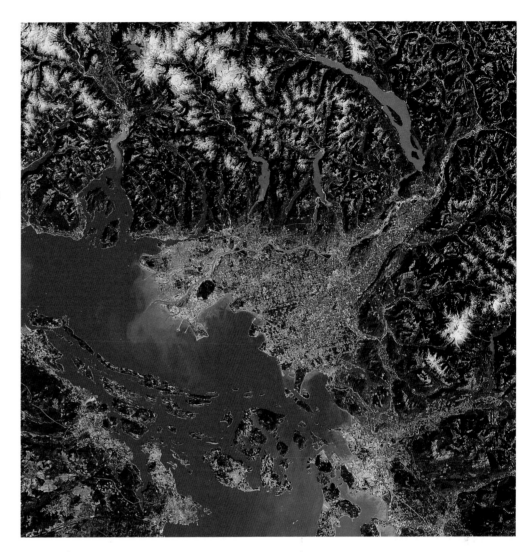

systems have proved so versatile and pow-erful—to governments, institutions, busi-nesses and individuals—that Macquarrie's use of airborne thermal infrared imagery to fight forest fires is merely one of the thou-sands of ways societies the world over have come to rely on remote sensing.

In Canada, mapping the land, waterways and other natural resources has been an important part of economic and social development since European settlers arrived on its rocky shores in the 1500s. Yet because of this country's varied geogra-phy, rugged terrain, difficult climate and small population, taking stock of the sur-roundings has never been easy. Even as recently as 40 years ago, large parts of the

North had never been surveyed or mapped in any detail. It was then that the federal government launched the first national topographic-mapping programme, hiring private firms to take black and white aerial photographs of the entire country, from which maps were drawn. According to scientist Robert Ryerson at the Ottawa-based Canada Centre for Remote Sensing (CCRS), the federal government's lead agency in the development and support of remote sensing in Canada, that pro-gramme, along with our predominantly resource-based economy, triggered the development of a private-sector remote-sensing industry that now ranks among the world's best. Since then, Canadian

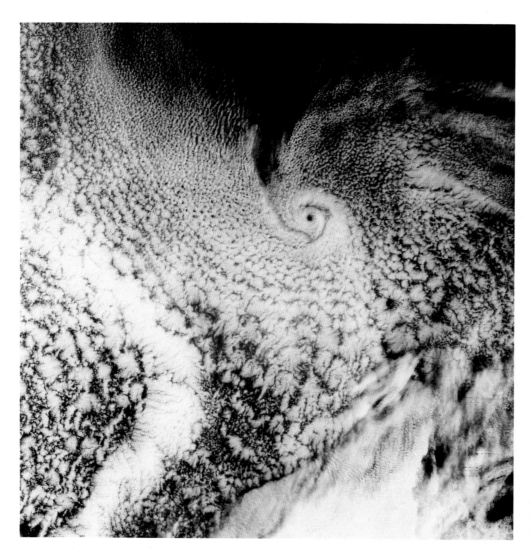

A severe storm, its cloud-spiralled eye captured by Landsat, forms over Davis Strait near Greenland in September 1973, above. In the past 20 years, satellite sensors have become an integral part of weather forecasting. The before, top right, and after, bottom right, T images at the site of a new dam and reservoir on the La Grande River in central Québec demonstrate the profound impact that dam construction has on the surrounding environment.

□ □ □ □ □ □ □ □ □ □ □ □ □ □ □ □ □

remote-sensing-related equipment, techniques and services have been exported to more than 100 countries. "Remote sensing is one field where our geography gives us a definite natural advantage," says Ryerson. "We have the biggest and best remote-sensing lab in the Western world."

If Canadian companies are among the world's leaders in the technology of remote sensing, the rest of the country's citizens stand as some of the world's most voracious consumers. There are very few maps in any car's glove compartment, in any new atlas or on the walls of any schoolroom today, for example, that are not by-products of some form of airborne or satellite reconnaissance. Likewise, weather fore-

casting and remote sensing are now virtually inseparable, to the extent that detailed images of clouds and weather systems gathered from meteorological satellites have become a regular feature on the television news.

In the workplace, the number of jobs directly linked to the availability and use of remotely sensed imagery is surprisingly large and still growing. The present list includes planners, resource managers, scientific researchers and consulting engineers, to name but a few. About the only possible drawback to such wide-ranging applicability is that it sometimes makes remote sensing a difficult, elusive field for lay people to understand or to appreciate fully. "There has always been a problem defining remote sensing, simply because it covers so many disciplines," says Diane Thompson, chairperson of the Canadian Remote Sensing Society and vice president of resource information services at INTERA Technologies Ltd. in Calgary, one of the world's largest remote-sensing firms. "You can treat it as a separate entity, best discussed by itself, or you can look upon it as one of the many different tools used in forestry, geology, urban planning and cartography."

No matter how it is defined, however, there is no doubt that remote sensing would not be the multibillion-dollar international enterprise it is today were it not for the stunning perspectives and vast quantities of information provided by detailed aerial photographs and other remotely sensed images of the Earth's surface. The plates that make up the bulk of this book are a prime example. Although they resemble colour photographs, they are actually computer-generated digital images of Canada obtained by the sensing systems aboard the Landsat series of resource-monitoring satellites launched by the National Aeronautics and Space Administration (NASA). Even before one considers their specific content, there is no denying that these exotic images have a striking visual appeal. Taken from heights of up to 900 kilometres, they reveal huge portions of Earth—about 34,000 square kilometres per

scene—as they might appear to someone looking down from space through a powerful telescope. The resolution may not be as fine as that of an aerial photograph (an object usually has to be at least 30 metres square before it shows up on a Landsat image), but aggregate patterns stand out so clearly that even vaguely understood relationships between geological processes, physical geography and human occupation come sharply into view.

This synoptic perspective also greatly increases Landsat imagery's value to the working world. A single Landsat image, for instance, can often take the place of several days' worth of expensive aerial photography or prolonged fieldwork where a survey of broad features rather than fine detail is required. Another of Landsat's important attributes, which it shares with every remote-sensing satellite, is its regular, predictable orbit. Landsat circles Earth on a 16-day cycle, making a total of 233 different orbits (14½ orbits per day) before it returns to the same location. It is over some part of Canada in the daytime every single day. At this pace, Landsat imagery offers a relatively simple and economical means of monitoring major changes taking place on the ground over time.

With its battery-recharging solar panels fully extended, a Landsat satellite is approximately three metres high and has a diameter of about four metres—roughly the same size as a late-model passenger van. Its sensors work like regular cameras insofar as they record the amount of visible light and near-visible infrared radiation being reflected from objects on the Earth's surface. Instead of producing an image by exposing that light directly onto photographic film, however, the satellite first divides the reflected radiation into as many as seven distinct spectral bands (blue, green, red and four in the infrared range), then electronically records the levels in the separate bands. Since every object on Earth absorbs and reflects light waves differently, this system is *theoretically* able to distinguish all types of ground cover on the basis of the unique reflectivity patterns, the so-called spectral signatures.

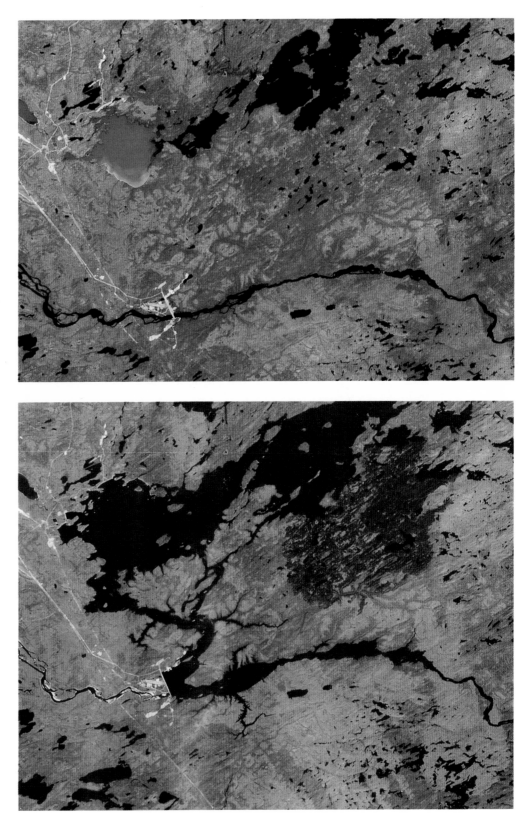

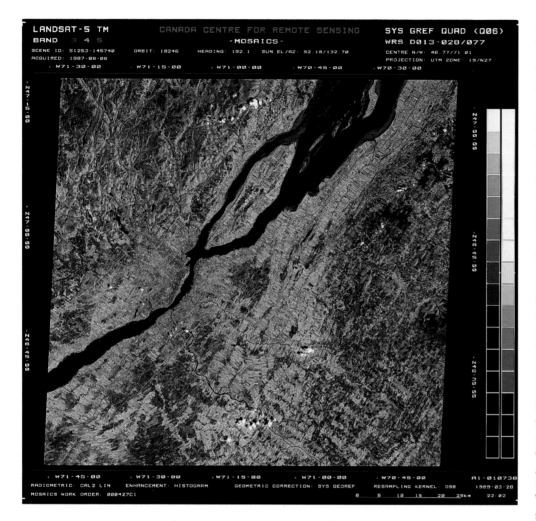

LANDSAT-5 TM CANADA CENTRE FOR REMOTE SENSING SYS GREF QUAD <Q06>
BAND 3 4 5 -MOSAICS- WRS D013-028/077
SCENE ID: 51253-145740 ORBIT: 18246 HEADING: 192.1 SUN EL/AZ: 52.18/132.70 CENTRE N/W: 46.77/71.01
ACQUIRED: 1987-08-06 PROJECTION: UTM ZONE: 19/N27
 . W71-30-00 . W71-15-00 . W71-00-00 . W70-45-00 . W70-30-00

 . W71-45-00 . W71-30-00 . W71-15-00 . W71-00-00 . W70-45-00 A1-010730
RADIOMETRIC: CAL2 LIN ENHANCEMENT: HISTOGRAM GEOMETRIC CORRECTION: SYS GEOREF RESAMPLING KERNEL: 098 1989-03-20
MOSAICS WORK ORDER: 000427C1 0 5 10 15 20 25km 22:02

In other words, the data that go into a Landsat image do not merely distinguish rocks from trees or soil from snow but can separate diseased trees from healthy ones, clear water from murky or dry soil from wet, because each reflects light in a different pattern. To achieve such precision, every 34,000-square-kilometre scene (at 30 metres square spatial resolution) is initially composed of a staggering 252 million separate radiation readings—seven for each of the 36 million separate picture elements, or pixels, that describe a single scene.

Once acquired, all the information is converted into an electronic signal and relayed to ground-based receiving stations around the world. Landsat data covering all but a small slice of the east coast of Canada are received and processed at the CCRS's principal ground station in Prince Albert, Saskatchewan. A second station near Gatineau, Québec, receives data from another system (SPOT). Once the data have been received at either location and transferred to computer tapes, they can be used to produce as many images as are required.

Out of the seven spectral bands, only three are used to produce any given image. Since every object reflects differently in each band, their selection depends on what surfaces and features the person using the images wants to highlight. The choice of colours in the images is equally arbitrary and often bears little or no relation to what the human eye normally sees. The major reason for this is that invisible infrared light has no colour, so it must be assigned one in order to be represented. In such cases, the images are dubbed "false-colour composites."

For the right to collect and distribute these data each year, the CCRS pays $600,000 plus royalties to EOSAT, the private Maryland-based company that took over the marketing of Landsat data from the U.S. government in 1985. In turn, the CCRS now sells about $1 million worth of imagery annually. Customers can choose from either preprocessed images ($140 and up for a colour transparency) or digital data on computer-compatible tapes (ranging as high as $4,000 per scene) for use in their own image-analysis and processing systems.

One such customer, Ducks Unlimited (DU), has made extensive use of Landsat imagery since 1984. As an international conservation group whose aim is the preservation, creation and restoration of wetlands that provide critical breeding habitats for most of the world's waterfowl, DU has used Landsat to create the data base for its first comprehensive wetlands-inventory programme, covering some 900,000 square kilometres of northern prairie grass and parkland in western Canada and the northern United States. According to Robert Rempel, a research biologist working out of DU Canada's Winnipeg headquarters, the creation of such an inventory was an important step in the group's efforts to establish subsequent comprehensive wetlands-conservation programmes.

To compile this inventory, DU Canada had to purchase digital Landsat tapes from Canadian and American suppliers for approximately 60 different scenes. With the use of a specially designed computer system, researchers in the group's Chicago headquarters have extracted and compiled wetland information on these tapes in two formats: maps and statistical summaries. The maps not only reveal the location and shape of wetland areas in relation to farmers' fields and other ground cover but also clearly identify three main categories of wetland: open water, deep marsh and shallow marsh. For the statistical summaries, each wetland is first assigned an

identification number. The system can then locate a given wetland and report how large an area it occupies, the distribution of open water, deep marsh and shallow marsh, the length of its perimeter and the relative irregularity of its shoreline (the more irregular it is, the better the habitat it provides).

According to Rempel, this information has already proved its worth in many ways. In planning for a project that would lead to the development of marshes and nesting cover in Manitoba, for example, Rempel and his colleagues at DU Canada were able to survey hundreds of townships in order to isolate specific quarter sections where the programme would be most successful.

"It would have been impossible to do that kind of resource planning by ground reconnaissance," says Rempel. "And if we had tried to do it through aerial photography, it would have cost millions of dollars more than we spent."

As if saving money while enabling DU Canada's workers to look after more territory is not enough, Rempel hastens to note that use of the Landsat system has also turned up important intermittent wetlands in southern Alberta that no one in the organization had ever seen before. "They weren't on the Canadian government's 1:50,000 series of topographic maps," he says. "Until recently, we didn't even know they existed. Now, we're formulating plans to protect and develop them."

The 60 scenes that went into DU Canada's data base were obtained by the two most recently launched Landsat satellites, Landsat 4 (1982) and Landsat 5 (1984), the only two remaining Landsat satellites that are still fully operational. Landsat 1, which kicked off the programme in 1972, was shut down in 1978. Versions 2 and 3 stopped working in 1982 and 1983, respectively. A sixth Landsat satellite is tentatively scheduled for launch sometime in 1991. However, diminishing financial support from the United States' federal government in recent years has put the programme's entire future in doubt. Early in 1989, EOSAT threatened that the only

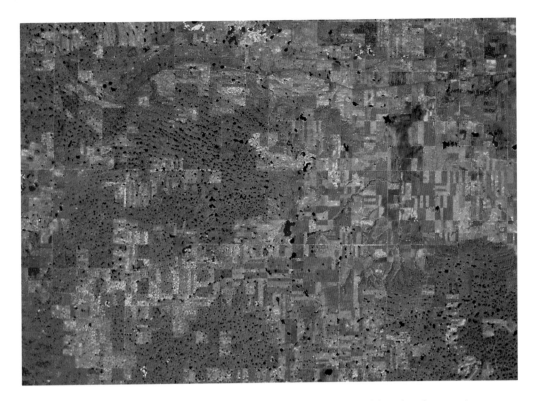

way it could afford to go ahead with plans for a sixth and seventh satellite under its current budget was to shut down Landsat 4 and Landsat 5 immediately. A crisis was averted, however, when the newly inaugurated Bush Administration came through with extra funding.

Even if there are no further financial problems, Robert Ryerson of the CCRS says there could still be a gap of at least a year between the time Landsat 5 runs down and the time Landsat 6 becomes operational. Add to this the fact that several other countries launched competing remote-sensing satellites in the late 1980s, and it is easy to see why some, such as John MacDonald, cofounder of Canada's largest privately owned remote-sensing firm, MacDonald Dettwiler and Associates Ltd., believe that the Americans may have "dropped the ball" at a critical juncture for the industry. MacDonald, whose B.C. company has built entire ground stations all over the world, fears that the hesitation shown by the United States might have dulled the competitive edge of the landmark venture.

Among the programmes that are

To assist in its habitat-development programmes, Ducks Unlimited Canada has made extensive use of Landsat imagery since the early 1980s. The image above, taken near the town of Mortlach, in southern Saskatchewan, indicates that small wetlands are scattered among the area's native prairie pasture. Left: Each day, the Canada Centre for Remote Sensing receives and stores information for about 70 new Landsat images of Canada. To ease retrieval, each image has an assigned number and numerous codes. This image of the Québec City region indicates that it came from Landsat 5 on orbit 18,246, August 5, 1987. Centre N/W gives the longitude and latitude of the centre point of the image; Heading notes the direction the satellite was travelling; Sun El/Az gives the sun's elevation and related azimuth.

□ □ □ □ □ □ □ □ □ □ □ □ □ □ □ □

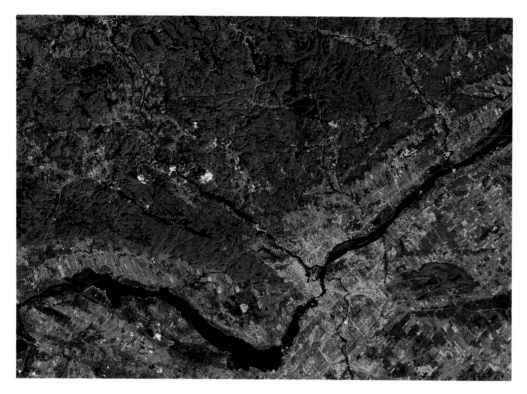

While Landsat can only record objects larger than 30 metres square, colour SPOT images show objects as small as 20 metres. Black and white SPOT images focus down to 10 metres. These two SPOT images of the Ottawa area indicate the system's finer focus (compared with a similar Landsat image on page 75), which, in the case of the black and white version, even gives a clear indication of major streets. Under strong magnification, these pictures prove useful to engineers planning routes for pipelines, highways and power lines; the less focused colour SPOT material is used more for resource management. SPOT, developed in France, tracks a narrower swath of Earth than Landsat, supplying finer detail at a higher price; an area recorded by Landsat might need two to nine times as many passes by SPOT.

□ □ □ □ □ □ □ □ □ □ □ □ □ □ □ □ □ □ □

now either operating or under full-scale development in other nations, says Mac-Donald, Japan's remote-sensing entry is most likely to succeed (the CCRS recently began receiving Japanese data at its Gatineau station). But there are other contenders. India and Pakistan are lobbying hard for their newly orbiting satellites. It is even possible to purchase a certain amount of data from the Soviet Union, which has its own remote-sensing satellites in orbit. However, the biggest push seems likely to come from the satellite series that has already garnered the most attention after Landsat in the Western world: the SPOT (*Système Probatoire d'Observation de la Terre*) system from France.

The first SPOT satellite went into orbit in early 1986. Unlike Landsat, which began life as a scientific research programme, the provision of SPOT data was intended to be a commercial venture from the outset. To this end, the French, Belgian and Swedish governments financed the design, construction and project launch, but the upkeep, sale and distribution of SPOT data are being handled through a separate com-

pany. Given this profit motive, it is probably not surprising that SPOT images cost more per unit area to obtain than do Landsat images: the CCRS, which receives SPOT data for Canada at its Prince Albert and Gatineau ground stations, charges almost $1,000 for each SPOT colour transparency, three times the most expensive Landsat colour image, and SPOT usually covers less than one-quarter the area.

Besides price, there are several notable technological differences between the two systems that often determine whether potential users opt for Landsat or SPOT data. Landsat scenes are larger than SPOT's, for example. Each time a Landsat satellite passes over Earth (the images are taken as it circles from north to south in a near-polar orbit), it scans a 185-kilometre-wide swath. The widest SPOT scene is only 117 kilometres. But what SPOT lacks in breadth, it makes up for in detail. While the best spatial resolution Landsat can manage is 30 metres square, SPOT is capable of 20 metres square in colour and 10 metres square in black and white. SPOT's sensors can also be aimed to record scenes as far as 475 kilometres east or west of the satellite's orbital track. Landsat's sensors can view only the surface directly below them. According to Ryerson, this capability for so-called off-nadir viewing gives SPOT the added benefit of being able to revisit the same scene at least twice a week. "This makes it more useful than Landsat for monitoring localized events like floods or forest fires," he explains. "Off-nadir viewing also allows SPOT to record the same surface from different angles to produce stereoscopic pairs of images. These can be used to make small-scale topographic maps."

The satellite that could have the biggest impact on the Canadian remote-sensing scene in the next decade is one still making its way from the drawing board to the launchpad. Radarsat, Canada's first remote-sensing satellite, is targeted for lift-off (on a NASA rocket) in either late 1994 or early 1995. Already, it is difficult to go far in any discussion about remote sensing before the subject—not to mention the superlatives—comes up. "Radarsat will be

the most significant remote-sensing satellite of its time," says MacDonald, whose company is also a major subcontractor for the $725 million project's ground equipment. "It will have a heftier power supply than any of its predecessors. Like SPOT, it will also be able to capture different views of the same scene."

Radarsat, as its name suggests, will also be a radar (or microwave) satellite. As such, it differs from both Landsat and SPOT, which operate in the visible and near-infrared regions of the electromagnetic spectrum. They are further differentiated by the fact that the source of the radiation recorded by the Landsat and SPOT sensors is reflected sunlight, whereas a radar satellite generates its own microwaves. In other words, its sensors go to work only when the waves that have been beamed down to the Earth's surface by the satellite are reflected back into space. Otherwise, the principle is much the same as with optical satellites. Since every object and every surface reflects radar waves with a distinctive character and intensity, it is possible to analyze the patterns, identify objects and construct images of the surface. Rather than identifying objects by their spectral characteristics, radar distinguishes items by their relative texture.

Supplying its own radiation instead of relying on reflected sunlight provides radar with at least one obvious practical advantage: unlike Landsat or SPOT, it can be used anytime, day or night. Even more important is the fact that microwaves can penetrate cloud cover, while visible and most infrared wavelengths cannot. "These features make radar a natural choice for the Canadian programme," notes Ryerson. "We have a lot of clouds over parts of this country, and in the high Arctic, it's also dark for much of the year."

The future satellite's potential is already evident in the work that airborne radar systems are doing over Canada and around the world. Radar's cloud-penetrating ability has made it possible to map and monitor forest-depletion rates in many tropical rain forests—an important step toward preserving them. Meanwhile, year-round in the

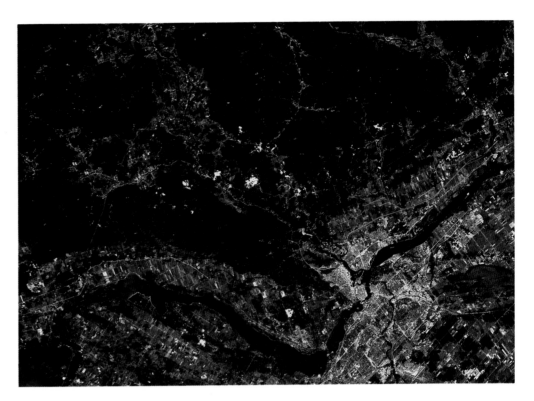

Arctic, as well as during the winter on both coasts and up the St. Lawrence River, the Ice Services Programme of the Atmospheric Environment Service (AES) now relies on several radar-equipped planes for a large part of its ice reconnaissance. The information is vital to anyone planning to take a ship through frozen waters and to oil-rig operators bobbing in a wintry sea. "We're not in the remote-sensing business," explains Donald Champ, director of the ice branch, from his office in AES's Toronto headquarters. "But it's our job to provide a decision support system for these people about ice. To do that, we have to know what the ice is doing now and what it's going to do in the future."

Synthetic aperture radar (SAR) systems—the same kind which will be used in Radarsat but which are carried by plane rather than by satellite—help out in the process by producing an image that clearly distinguishes open water, relatively soft first-year ice, harder multiyear ice and floating icebergs. Given its 10-metre resolution and its flexibility to scan Canadian waters every 72 hours, Radarsat is expected to

do the job with nearly equal precision and timeliness.

Whether such attributes will be enough to allow AES to dispense with its airborne radar is another matter. According to Champ, the lack of a backup satellite means that he still cannot run the risk of pulling his aircraft out of service. "Even so, Radarsat will certainly save us the incremental costs of some flying," he predicts. "But when you consider we also use icebreakers, helicopters and other airborne and satellite remote-sensing systems, even a second Radarsat satellite wouldn't meet all of our needs."

To ensure that there are other, more reliable applications and markets on hand for Radarsat's data and imagery once they are available, the federal government has established a 15-year radar-data development programme with a $5 million annual budget. While the emphasis is on resource management in general, much of the work has been tailored toward agricultural applications. Since 1987, the CCRS and the Manitoba Remote Sensing Centre have been working on a computerized crop-

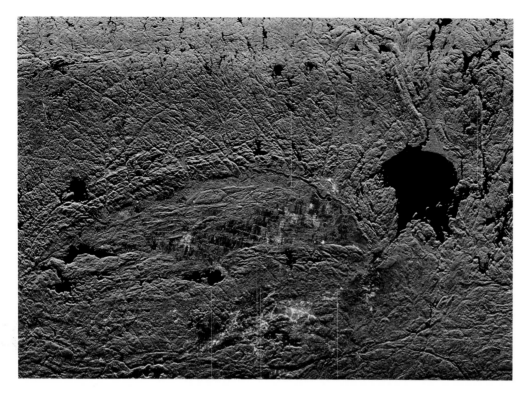

Synthetic aperture radar's (SAR) high resolution and flexibility allow it to detect faults and surface roughness, characteristics that make it an important mapping tool. The Sudbury region, above, offers SAR a unique challenge: scientists consider it to be the largest meteor impact site on Earth, it contains massive deposits of copper and iron ore, and it is the meeting place of the three geological structures that make up the Canadian Shield. Right: Infrared film adds an eerie cast to the aerial photograph of a Thornhill, Ontario, golf course and housing development, parts of which are still under construction. Much more detailed than a satellite image, this scene captures individual trees, cars and even golfers.

information system using relatively low-resolution (1.1 kilometre) visible and near-infrared imagery from a series of orbiting meteorological satellites to monitor overall vegetation conditions in western Canada. While the current version is really only a preliminary design that will be modified by the time Radarsat is launched, the Regina-based Prairie Farm Rehabilitation Administration (PFRA) is already using the data —which are updated weekly—to help determine compensation for farmers afflicted by drought and heat waves. "This technology allows us to look at the vegetative vigour of a large area and compare locations directly," says Elliott Allison, the PFRA's environmental studies coordinator. "Last summer, I spent four days in the field in one area northwest of Regina, driving back and forth, putting in long hours. Afterward, I found that I learned more about crop and soil conditions in that area by ordering one image. Plus I had the information in a quantitative form."

By the time Radarsat starts sending back images from space, more than 20 years will have passed since Landsat 1 was carried into orbit. The number of remote-sensing satellites circling Earth by then may be into double figures, and their usefulness will be more widely known than ever before. According to Ronald Eyton, a geography professor and remote-sensing specialist at the University of Alberta, in Edmonton, the present trends toward higher spatial and spectral resolution, directable scanners, increased frequency of coverage and expansion into more of the electromagnetic spectrum are likely to continue in future satellite programmes. "At the same time, as the number of satellites and the number of users continue to rise, future systems are going to be much more specialized," he adds. "They're going to be aimed at doing particular types of tasks, as opposed to providing general coverage."

But the familiar obstacles of high up-front costs, an immature market and the limits of technological know-how are not the only factors affecting this evolution. Civilian remote-sensing satellites face a peculiar added constraint: military and/or government concerns about privacy and national security. "The military has access to more sophisticated sensing systems and better-quality imagery and resolution than you're now seeing in the civilian community," explains Eyton. "The reason you haven't seen them trickling down to the public is that they [the military] initially put the clamps on the sort of resolution and retrieval times civilian satellites could offer."

Just how wide a gap exists between military and civilian remote-sensing systems is a matter of some speculation. From time to time, rumours circulate about electronic imaging and photographic systems so powerful and so invasive that they could read a car licence plate from a satellite platform. As incredible as they sound, says Eyton, these claims are not too farfetched —"if we can assume cars have licence plates on their roofs." There is no doubt, he adds, that there are military satellites in use which are capable of spatial resolutions on the order of "a few square metres."

If this is the case, such civilian restrictions are hardly surprising—a resolution limit is probably the only way to prevent those

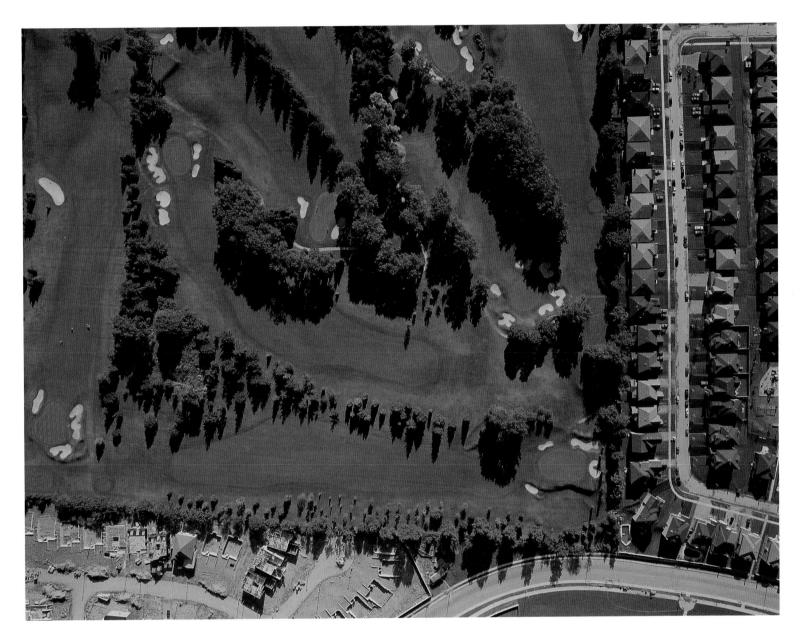

countries without their own spy satellites from using public data to probe the details of another country's sensitive installations. The same concerns are not likely to apply with airplanes, of course, because they must have permission to enter another country's airspace. By comparison, satellites are still (for now) free to go where their operators please.

At the same time, if past history is any indication, today's military state of the art could still find its way into future civilian sat-ellite systems. Most of the aerial photogra-phy equipment and techniques used in the development of Canada's remote-sensing industry in the 1940s were produced or perfected by the military during World War II. The development of Landsat and other satellite imaging systems grew out of the American Apollo space programme (a joint military-scientific effort) in the 1960s. "To land a man on the moon, the Americans had to develop all sorts of reconnaissance techniques to image the surface," explains Eyton. "They did it from orbit; they did it by crash-landing rockets on the moon; they even planted robot landers right on the lu-nar surface. Many of our current remote-sensing imaging techniques were based on techniques used in these missions."

Amid all the glamour and hype that sur-round the use of remote-sensing satellites, it is easy to lose sight of the fact that airplanes still account for the lion's share of the work in this field. Besides their lower cost, an important reason for their dominance is

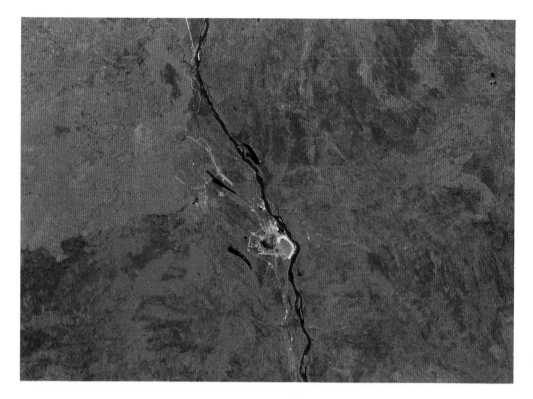

sors also doing their share of impressive service. Among them: laser scanning systems that measure and chart coastal waters up to 40 metres deep; laser and spectral ''fluorosensors'' capable of detecting fluorescent emissions that mark everything from oil spills and other marine pollution to the location and concentration of phytoplankton, the first link in the oceanic food chain; and multispectral imagers similar to the sensing systems aboard Landsat that are being used for assorted resource monitoring and mapping applications.

Still more systems and techniques are being added to the list almost daily. In fact, between airplanes and satellites, it is becoming increasingly apparent that the use of remote sensing has actually reached the point where having too much information could be of as much concern as not having enough to go around. Instead of being swamped by all the data pouring down from the skies, however, the remote-sensing world is out to make the most of it. In the process, it is turning to powerful computer systems like the one in use at Ducks Unlimited. In a single package, such systems combine the newest microprocessors, engineering-calibre display terminals and integrated graphics and data-base software. The combined result of the technology and data, remotely sensed or otherwise, is a powerful tool known as a geographic information system (GIS). With it, anyone who can tap a few keys on a keyboard can extract, display and plot a map of any combination of data almost instantly. ''In some ways, it is an extension of what we've already been doing piecemeal,'' says Ronald Eyton. ''Nevertheless, GIS is going to revolutionize the way we operate.''

Hunter, whose firm has been in the business of designing and selling GIS long enough to boast 40 or 50 installations, offers an even stronger endorsement. ''Just as satellites were the wave of the 1970s and early 1980s, GIS is really the focus of the industry today,'' he says. ''It's where we're doing most of our internal research and development. It's where I think the growth in our business is going to be.''

The most widespread use of the system

simply that airplanes and many airborne sensors have been around a lot longer than satellites, giving people more time to learn about them and to develop techniques for their use. And for all its impressive capabilities, remote sensing by satellite still lacks the airplane's versatility, timeliness, accuracy and predisposition toward important detail. And detail, according to Garry Hunter, founder and president of Hunter and Associates—a Mississauga, Ontario-based environmental and engineering consulting firm involved in airborne remote sensing—is what most of his business is all about. ''We're getting more and more demand for low-altitude flying,'' he says. ''Designers in urban areas, for example. They want to see the hydroelectric poles and the light poles and all the infrastructure. With our aerial cameras, we can see down to just a few centimetres. They want that kind of detail. People everywhere are just demanding better and better maps.''

The walls in Hunter's offices are covered with aerial photographs (black and white, colour and infrared). In one room, a large colour print of a photograph taken over a

golf course hangs next to a Landsat scene depicting a broad chunk of southern Ontario terrain. The juxtaposition serves to reinforce the contrasting scales and levels of detail provided by the two technologies. To make sure there is no doubt about where his bread and butter is, Hunter points to the aerial photograph: ''If you look closely, you can even make out a few golf balls.''

Besides providing vital information for designers, architects, developers and municipal planners in urban areas like Metropolitan Toronto, photographs taken by Hunter's firm form the basis of scores of larger projects, ranging from forest inventories to shoreline-conservation studies. Where they do make use of satellite imagery, says Hunter, it is usually as an adjunct to more extensive and detailed aerial photography.

Nevertheless, as the earlier examples of airplane-mounted radar and thermal infrared scanning systems already indicate, aerial photographs make up only one element (albeit the largest) in the overall field of airborne remote sensing. In fact, there are a large number of other ''electro-optical'' sen-

to date is occurring in those sectors where remote sensing and mapping have long been a part of everyday life. In addition to the military, they include the forestry and mining industries, public and private utilities and several levels of government administration. In the long run, though, Hunter believes GIS's most telling legacy will be its ability to bring the power of maps and spatial thinking to a wider range of people than ever before. "It's an integrator of so many things and so much information," he says. "People we show it to love this stuff because it pulls together so much data and displays it in ways they've never even considered."

Despite the great promise of GIS technology, however, its emergence and rapid proliferation are not without drawbacks. If the increased use of maps is indeed going to pay dividends, a lot of people will require a level of graphic and spatial literacy that they have never had a chance to develop. At the same time, because more and more responsibility for data classification and image processing and interpretation is handed over to a single highly automated computer system, there is also an increased likelihood that even a minor programming error or data omission could produce far-reaching setbacks. For Eyton, the critical lesson is that people using GIS simply must not lose sight of such limitations, nor should they forget that everything in GIS is in some way nothing more than an approximation or a simplification of the "real world" beyond their office doors. "Otherwise, I think there's a temptation to forget that it's just like any tool," he says. "In that sense, using it is always going to be as much an art as it is a science. It will still depend on the person's knowledge of the phenomena he or she is working with."

The same cautionary note can be extended to every aspect of remote sensing, from the production and use of the simplest aerial photographs to the most sophisticated computer-generated satellite images. However clear and precise the pictures appear, there will never be a perfect substitute for firsthand knowledge about what is actually out there on the ground. "Remote

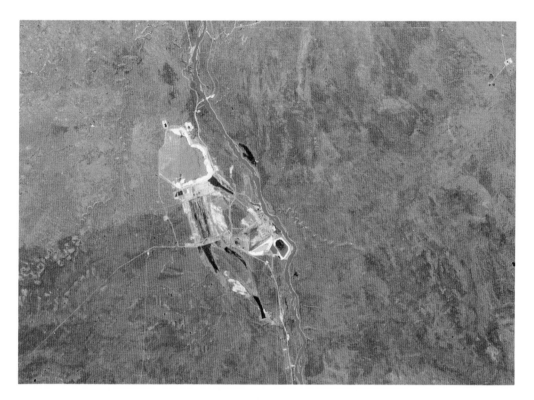

sensing is not the be-all and end-all," says Robert Ryerson of the CCRS. "It's really just one more data source. By itself, it cannot tell you where to drill a well or where to plant your trees. To do that, you also have to have local knowledge."

The recognition that remote sensing is, in essence, nothing but a tool also underscores one important final point: ultimate responsibility for its proper application rests with the people and organizations that use it. It is a grim irony of the technology, then, that for every hectare of prairie wetland or tropical rain forest which remote sensing is helping to preserve, another fragile northern ecosystem is just as likely being exposed to the ravages of oil and mineral exploration, or the last of this country's free-flowing rivers is being forced into submission behind towering concrete dams. A similar story emerges in many of the images that follow. At the same time as they reveal the planet's enormity and beauty and humanity's own inherent smallness, there is no mistaking the telltale signs of reordering and destruction that our tiny yet incredibly powerful hands have wrought.

Although the existence of the oil-saturated sands along the Athabasca River in northeastern Alberta was known to traders 200 years ago, large-scale extraction was not undertaken until the early 1970s, in an attempt to create a domestic oil supply. The earlier image, left, taken in 1973, illustrates a modest level of activity; by 1981, above, the development of the tar sands was a major focus of new construction and excavation, and several huge pits, pools and associated buildings had emerged.

□ □ □ □ □ □ □ □ □ □ □ □ □ □ □ □

QUEEN CHARLOTTE ISLANDS, BRITISH COLUMBIA

□ □

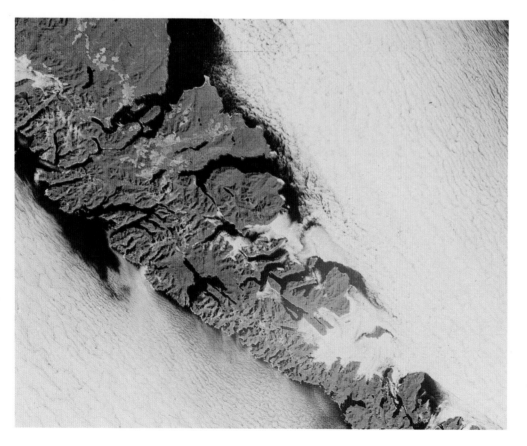

Home to the Haida Indians for centuries and occupied by their native ancestors as early as 5000 B.C., the Queen Charlotte Islands are now a modern-day cultural and environmental battleground. The recent focus of the struggles—in which the economic interests of British Columbia's forest industry are pitted against native claims to territorial sovereignty and the preservationist goals of a broadly based environmental movement—is Moresby Island, the largest island in the lower half of both images (its separation from Graham Island, above it, is barely discernible but is more clearly shown in the older, cloud-enshrouded image, left). In 1988, a 14,070-square-kilometre segment of South Moresby, site of some of Canada's last stands of native Pacific rain forest, was designated a national reserve. Disputes over its administration and management persist, but the decision represents an important victory for both the Haida and environmentalists. At the same time, the white, blue and pink patches (indicating current and former logging sites) on the other islands suggest that logging companies are still active.

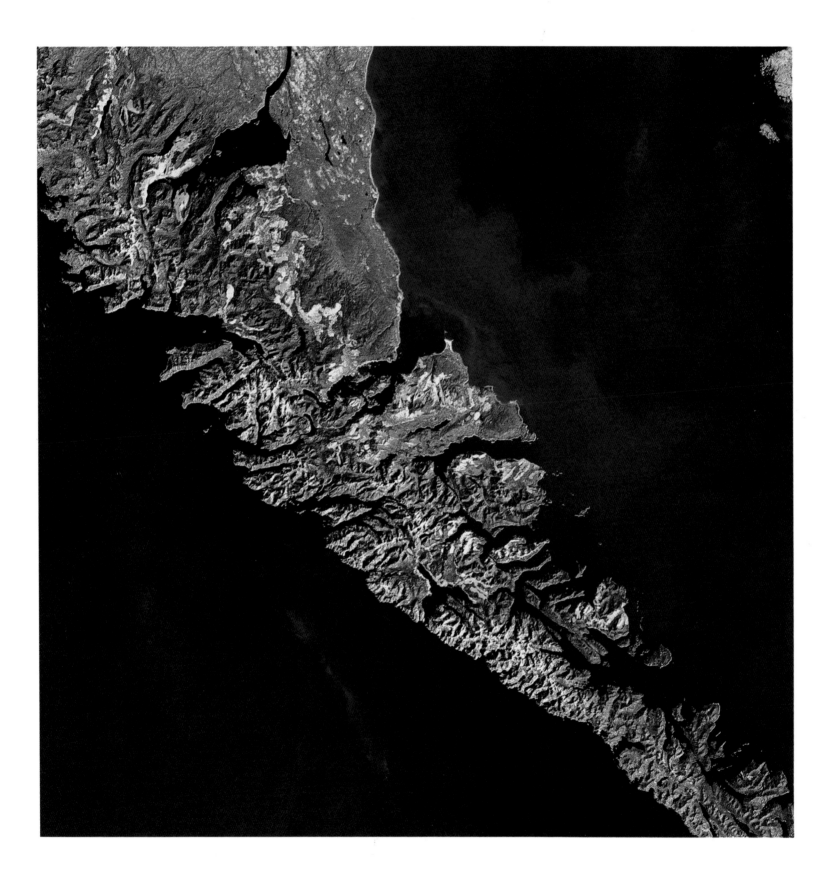

Few places in British Columbia are more "British" than Victoria, the provincial capital, shown here in dark blue at the southern tip of Vancouver Island, far right. Founded in 1843 with the construction of Fort Victoria, the city now contains a metropolitan population of approximately 250,000. A large number of these people are retired seniors, attracted by the city's easygoing traditional character as well as its gentle climate—moderated year-round by mild Pacific air, Victoria is Canada's warmest city, with a mean annual temperature of more than 10 degrees C.

Built on a narrow peninsula overlooking the innermost waters of Juan de Fuca Strait and Washington's Olympic Mountains beyond, bottom, with Vancouver Island's own Seymour Range and the Gulf Islands, top

right, as a backdrop, Victoria is appreciated by young and old alike for its spectacular setting. The physiographic forces responsible for such an arrangement are diverse and complex. Two-hundred-million-year-old lava flows, subsequently uplifted and eroded, form the backbone of Vancouver Island itself. Recent glaciation is responsible for the present depth and configuration of the waterways, while their original existence can be traced to a system of wide troughs that divide the outermost coastal mountains from the interior along most of North America's Pacific Coast.

The town of Duncan is visible at the head of the deep harbour, top centre. Large logging scars can be seen over much of the island (see detail, left), with the pink and yellow tones indicating recently cut areas.

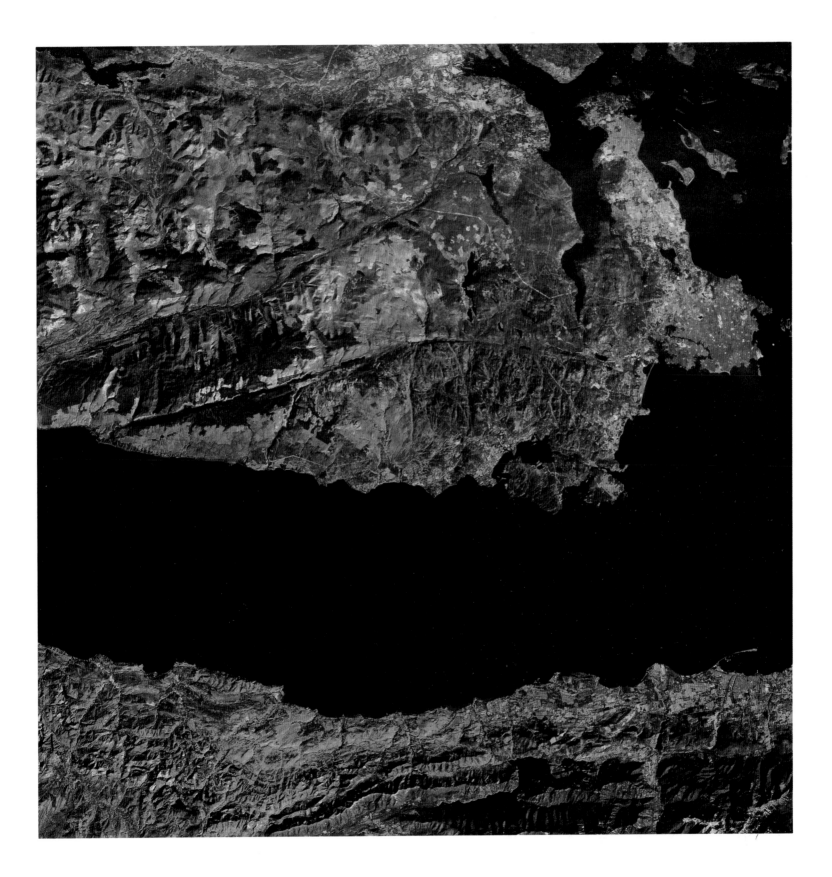

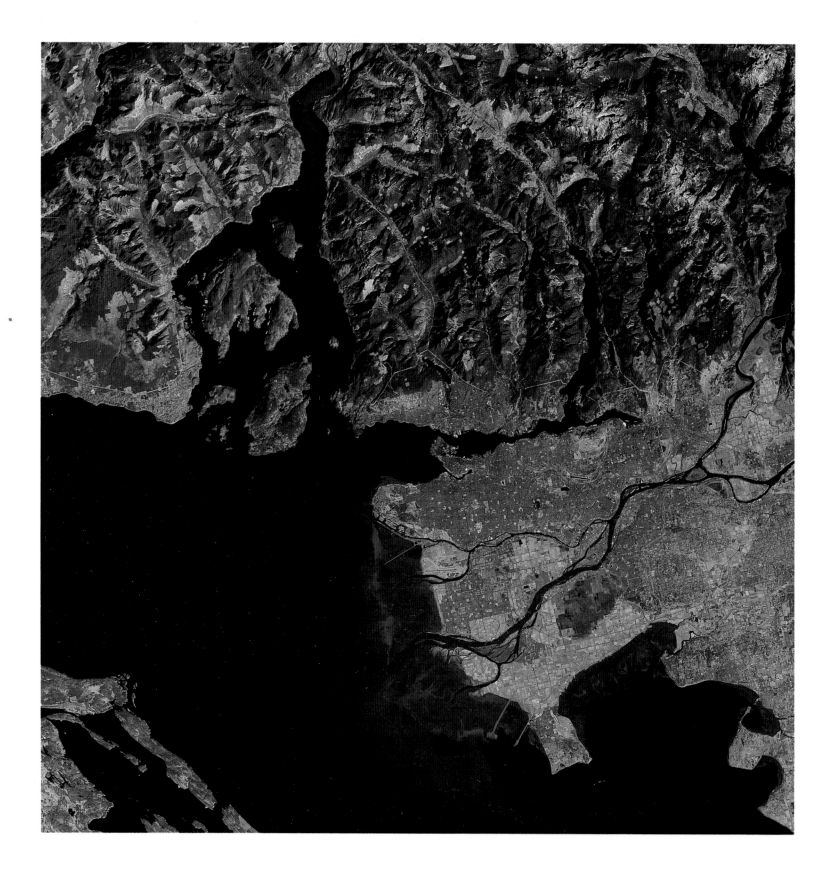

Although British Columbia covers an area of about 950,000 square kilometres, almost half of the province's three million citizens are squeezed into the several hundred square kilometres of relatively flat, fertile land that makes up the Fraser Delta. Formed at the mouth of the Fraser River, where it spills into the Strait of Georgia after travelling some 1,370 kilometres from headwaters near the B.C./Alberta border, the delta continues to grow, as evidenced by the plumes of river-borne sediment swirling out into the strait's deep blue waters.

The upper third of the delta is dominated by Vancouver. Here, downtown Vancouver is clearly visible on the delta's northern edge, in deep blue, as are the adjacent forested peninsula of Stanley Park, in deep green, the paved runways of Vancouver International Airport, pink, and even the circular dome of B.C. Place Stadium (a bright white dot in the midst of Vancouver's urban blue). Numerous other cities (marked by blue clusters) follow the Fraser and Highway One back into the mountains. The remainder of the delta bears the patterns of intensive agriculture, with market gardens predominating on the "flatlands" near the ocean and dairy farming occupying much of the higher ground to the east. South of the point where the Fraser's main channel empties into the strait, the Roberts Bank Superport and the Tsawwassen ferry terminal reach out toward the Gulf Islands and Vancouver Island, lower left.

The large inlet extending north into the mountains from the Strait of Georgia is Howe Sound, which terminates at the town of Squamish. Nearby mountain slopes play host to a small amount of logging, as indicated by the pale green and pink cutouts in the otherwise dark green forests.

Ice fields and alpine glaciers appear as blue-white frosting on the steep, reticulated Coast Mountains of British Columbia and the Alaska Panhandle. They are among the most southerly present-day remnants of the once mighty continental ice sheets. In their last major advance, the glaciers carved out the long, narrow, dark blue fiords that now penetrate as much as 50 to 100 kilometres inland from the Pacific Ocean. Their rivers of silt-laden meltwater leave pale blue trails at the head of each inlet.

Of the four major channels pictured entering from Hecate Strait just out of the image to the south, the two on the right are part of Canada and the two on the left are part of the United States. The actual border follows the longer Canadian inlet until it nears the isolated town of Stewart, on the valley floor near the centre of the image. Then it heads off to the northwest through the ice fields. The only other notable settlement visible on the image is Ketchikan, Alaska. The town itself and a large airport runway straddle the shoreline of a small channel in the extreme lower left.

A tiny segment of the Skeena Mountains is visible in the upper right-hand corner. The Skeena River, which flows from these mountains to the sea, is out of range to the south. An image of that river would also contain the town of Prince Rupert, which sits at the Skeena's mouth.

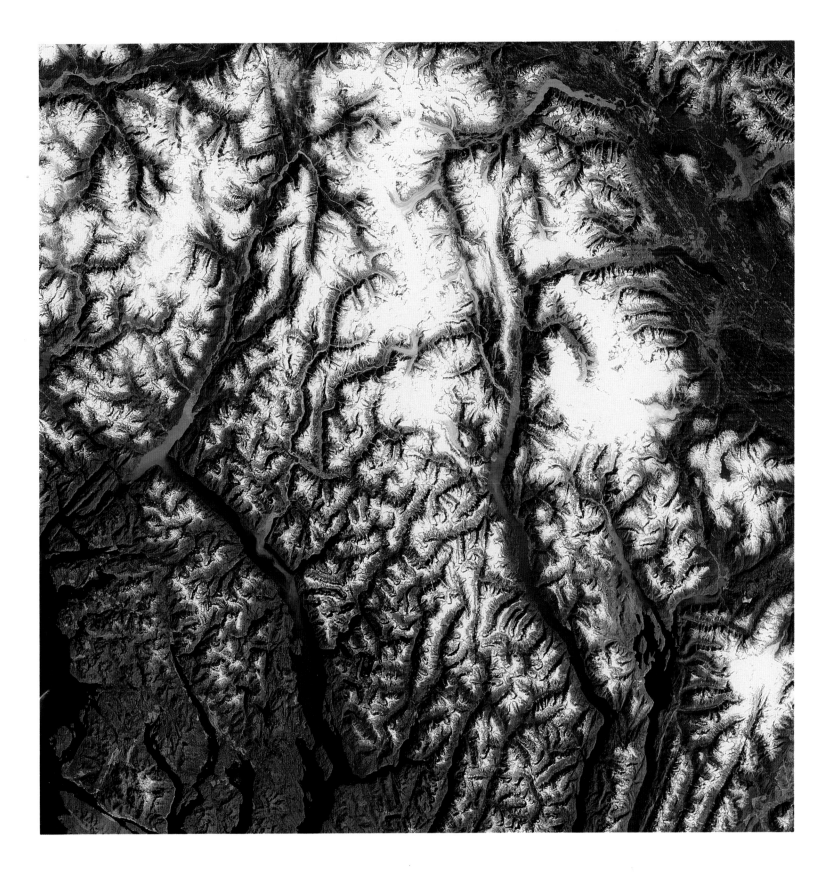

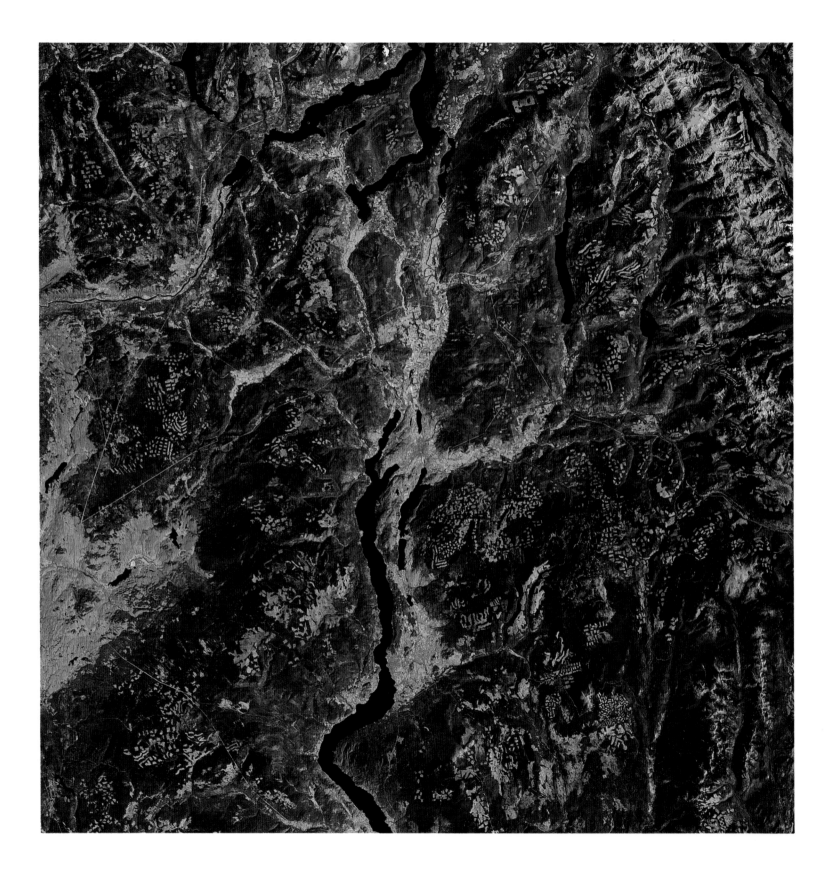

Deep in British Columbia's southern interior, the Okanagan Valley, centre, is one of the province's few important areas of intensive agriculture outside of the Lower Fraser Valley. Warm summers and a relatively long growing season have enabled orchards and vineyards to take hold on the hillsides and terraced slopes above Lake Okanagan. Numerous small communities catering to these activities, shown in deep blue, have also been established along the valley floor. The largest include Vernon, at the north end of the lake; Kelowna, farther south on the eastern shore; and Penticton, off the image at the lake's south end. Many parts of the Okanagan and other similar narrow, lake-filled valleys nearby are also important year-round destinations for tourism and recreation.

Agriculture and tourism are by no means the only types of land use in the area. Forestry is especially predominant on the hillsides and upper mountain slopes, as revealed by the dense patchwork of pink and pale green cutouts (indicating deforested areas in varying stages of regeneration) visible across the entire image. A little more than a century ago, the portion of the Thompson River cutting across the northwestern corner of the image just above Kamloops, far left, was the scene of British Columbia's first gold rush. The huge pink scar to the lower left of the image marks the location of Highland Valley Copper, the world's second largest open-pit copper mine.

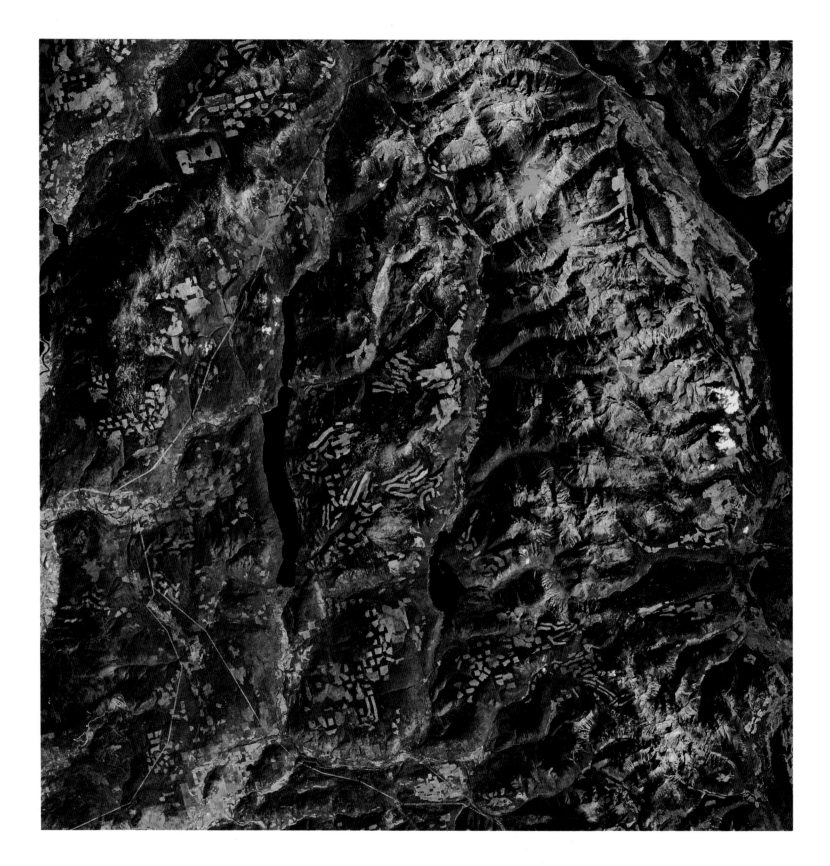

While cities and towns in British Columbia's mountainous southern interior are confined to the narrow valley floors, the reach of humans and their machines knows no such limits. Here, in a detail of the image appearing on the previous page, almost every hillside bears the familiar scars of intense, prolonged logging. Given the clear perspective that satellite imagery provides, it is hardly surprising that the B.C. Ministry of Forests now relies on satellites to maintain up-to-date inventories of wood stocks around the province. Area measurements are the simplest and most commonly used form of analysis, but sometimes it is also possible to use the images to monitor disease and insect damage or to determine degrees of growth and regeneration. In this instance, the pink strips and squares mark the most recently logged areas, while older regenerated sections show up in increasingly darker shades of green (the older the regrowth, the darker it appears).

The blue-crested mountains leading down from the top of the image are the snowcapped peaks of the Monashee Mountains. The long, narrow lake immediately to their right is Upper Arrow Lake, part of the Columbia River system. Farther up the valley, just beyond the northern edge of this image, is the town of Revelstoke. In the lower left, the northernmost fields of the Okanagan Valley stand out as a colourful blend of light green, blue and magenta. The town of Vernon forms a dark blue cluster in the extreme southwest.

□ □

Fed by a regular succession of Rocky Mountain tributaries, the milky blue Athabasca River makes its way north through Jasper National Park and into the Alberta foothills, at top. The town of Jasper is located on the Athabasca's western bank, at lower middle, surrounded by the snowcapped mountains and dense forests that bring thousands of travellers and tourists here annually. Highways following valleys to the southeast and the west from Jasper lead to Banff, Alberta, and Prince George, British Columbia, respectively.

The highway and railroad tracks heading west also cross the continental divide before reaching a small lake, at bottom left, site of the village of Lucerne and the head-waters of the Fraser River, which flows approximately 1,300 kilometres from here to Vancouver.

Slightly to the east and downriver of Jasper, Maligne Lake fills the entire valley floor, serving as a favourite hiking destination and a noted scenic locale. Farther east, as the Athabasca leaves the Rockies at Brūlē Lake, it crosses the national-park boundary.

Here, the dark red-brown shading that indicates dense, healthy forests gives way to a landscape marked by the lighter brown shades and familiar stripes and checker-board patterns made by widespread active logging. Still farther downstream is the town of Hinton, the site of Alberta's first pulp mill. Today, in addition to being a service centre for three local coal mines, Hinton is identified with one of Canada's worst railroad disasters—a head-on collision between a passenger train and a freight train that killed 29 people in 1986.

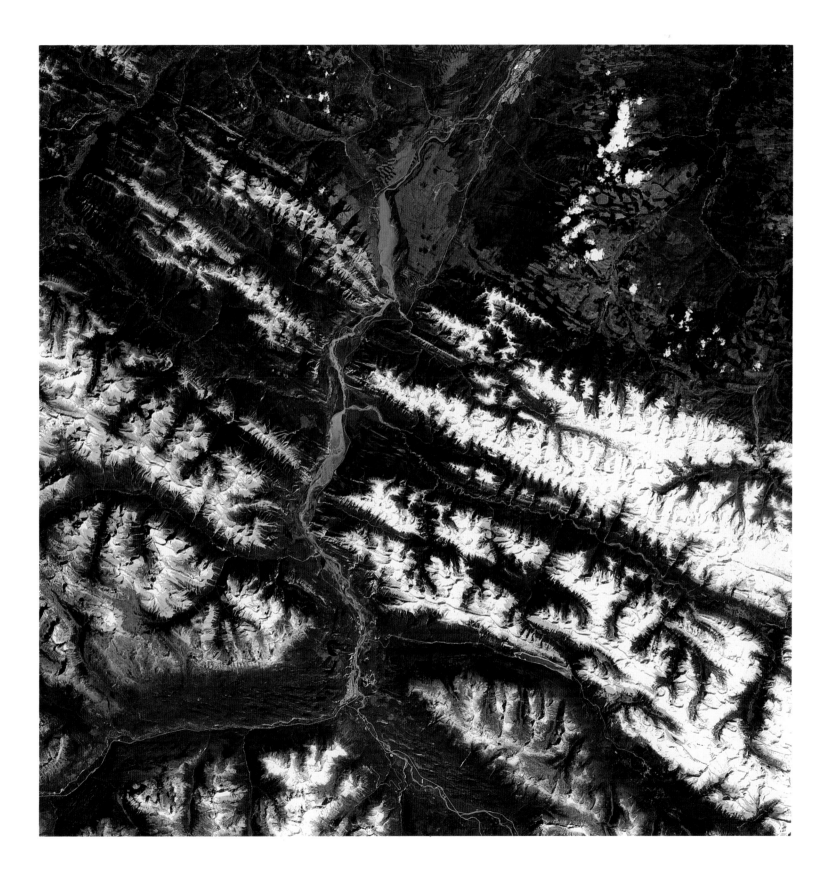

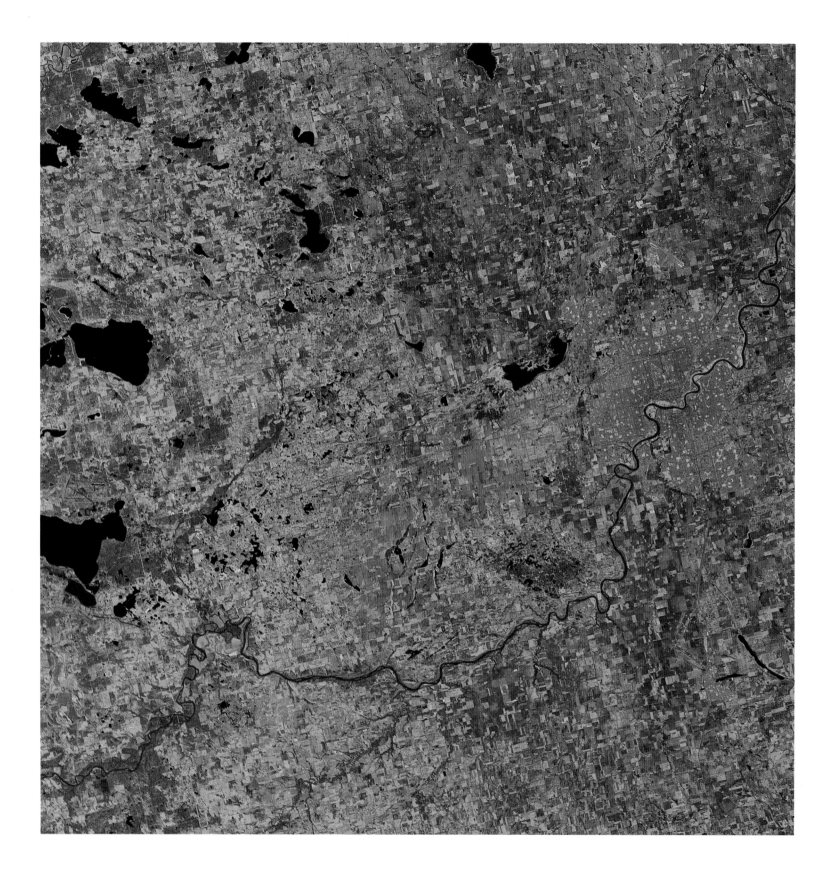

Founded in 1807 as Fort Edmonton, a Hudson's Bay Company trading post on the North Saskatchewan River, Edmonton (the blue-green mass in the right centre) now ranks as Canada's most northerly metropolis. Covering an area of more than 300 square kilometres and boasting a population of approximately 700,000, it is both Alberta's capital and its most populous city.

Like Calgary, its rival to the south, Edmonton is located at the western edge of the Great Plains. Not surprisingly, then, it is surrounded by a continuous expanse of intense agricultural activity (in this early-May scene, the pink tones indicate bare soil or newly planted fields). Slightly to the west, however, the plains yield to patches of rougher, higher ground that in turn give way to the foothills of the Rocky Mountains. The first of these nonarable outcrops show themselves as dark green (indicating tree cover). Glacial till and lake deposits are common across the entire image, as are numerous small lakes and ponds that provide important wetland habitat for nesting and migrating waterfowl.

Even more than for agriculture, however, Edmonton is noted for its prominence in the energy business. Natural-gas wells dot the landscape surrounding the city, while a large portion of the industrial property is given over to oil refining. Hundreds of huge petrochemical storage tanks are visible on the northeastern margins of the blue urban buildup, on the east side of the river. Ironically, it is at approximately this same point that Edmonton's 16-kilometre greenbelt begins along the North Saskatchewan's banks. That greenbelt is visible as a pale green ribbon flanking both sides of the river through much of the city.

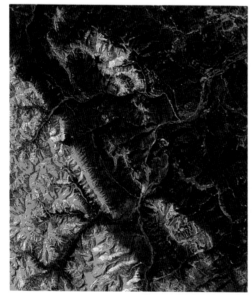

An extensive yet orderly urban sprawl characterizes Calgary's growth, shown in blue, as it spreads out evenly in all directions from the confluence of the Bow and Elbow rivers, where it got its start as a trading post in the mid-1800s. In the same way that it straddles these rivers, Calgary also straddles the transition from the green pastures and rangeland of the Rocky Mountain foothills to the deep pink of newly planted fields on the western edge of the northern Great Plains. This axial position has been central to Calgary's success, establishing it as a major service centre for the agricultural communities to the east and south while at the same time raising its stock as an important gateway for transportation and tourism to the Rockies farther west. Its location is also responsible for the

extreme vagaries of its weather, which can be cold and damp one minute and hot and dry the next.

The dark green forests that mark the first high ground of the Rockies quickly give way to snowcapped peaks, which show up as brilliant blue, in the extreme southwest (see detail, left). Before reaching Calgary, the Bow River descends out of the mountains from headwaters in Banff National Park (off the image to the northwest). At a point in between, the river skirts the boundaries of Kananaskis Provincial Park, site of the skiing events in the 1988 Winter Olympic Games. To the east of Calgary, the Bow—a popular spot for trout fishing—continues southward for several hundred kilometres, where it joins the Oldman River and the two become the South Saskatchewan.

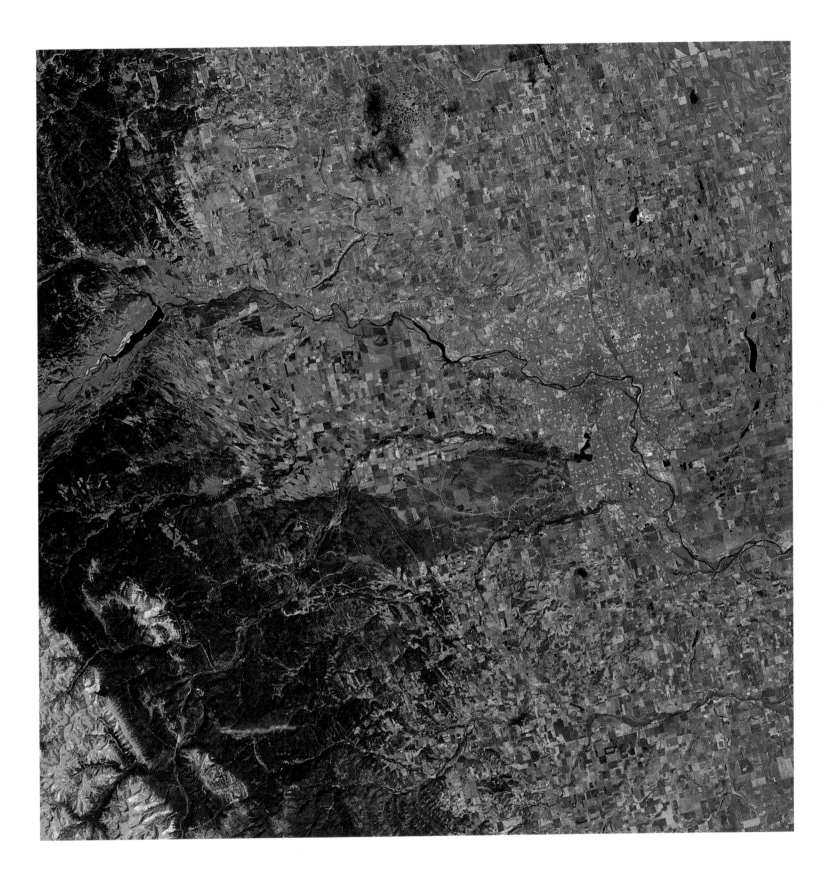

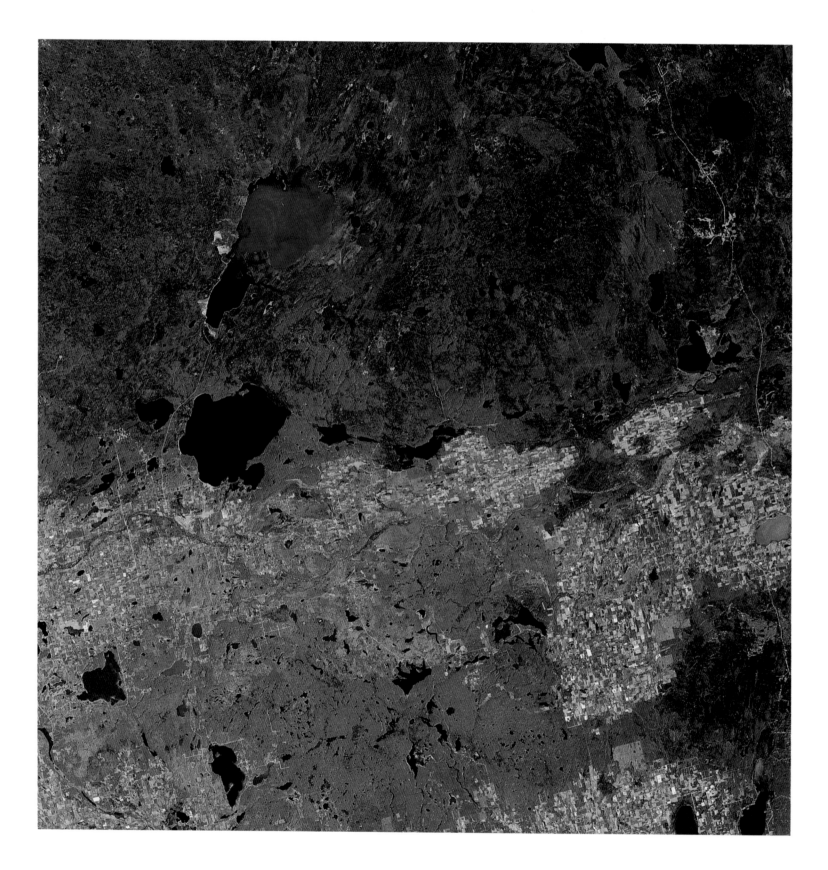

The Great Plains cover a stretch of continent from southern Texas to Great Bear Lake. Here, 850 kilometres north of Montana on the Alberta-Saskatchewan border, their familiar checkerboard pattern of farmers' fields (grain, canola and flax) gives way to a thinly populated aspen-spruce forest and scrubland.

The stunted forest is underlain by bits of the nearby Canadian Shield, along with plenty of loose rocks, gravel and other glacial debris. It is an erratic, poorly sorted foundation that has also produced a landscape pockmarked with hundreds of ponds and lakes. The largest seen here is Primrose Lake, with Cold Lake just below it. All but the lower third of Primrose Lake is in Saskatchewan, while approximately two-thirds of Cold Lake lies in Alberta. The town of Cold Lake and its adjacent Canadian Forces' air base show up as light blue patches immediately southwest of the lake itself.

If the image could be extended to the north, it would soon reveal a second transition into the vast boreal forest that encircles the globe at these latitudes. Images of the largely coniferous forest are remarkably alike, whether taken over northern Canada, Europe or Asia. It was precisely this characteristic—the fact that this part of Canada is much like the Soviet Union's northern flank—which prompted the United States' military to propose testing its cruise missiles over our country. Launched periodically since 1984 from B-52 bombers flying over the Beaufort Sea in the Arctic, the missiles are usually targeted for the Cold Lake region.

Like all lines of latitude and longitude, the 49th parallel was just an arbitrary, imaginary line when it was chosen as the Canadian/U.S. border from Ontario to Alberta in 1818. Today, however, it is every bit as real and tangible as the differences between the two countries on either side of the line; it is almost as though the symbols of political economy have been carved into the land.

The upper half of the image shows southern Alberta rangeland; below, the dense agglomeration of Montana wheat fields. The dramatic change in land use is not a function of soils or climate but of American agricultural policies that encourage and subsidize grain production and of Canadian policies that do not. The area shown centres on the Milk River, flowing southeast out of Canada and into the United States. Healthy vegetation is depicted in bright red. Recently harvested fields are white, while land left to fallow is a pale green.

As with most of the Great Plains, the rolling land on both sides of the border consists of poorly cemented silt, sand and gravel laid down in successive layers by parallel rivers and streams flowing east from the Rocky Mountains. Just out of sight to the northeast of this older Landsat image are the Cypress Hills, remnants of a 35-million-year-old plateau that has the rare distinction of being one of the few places in Canada bypassed by the last ice age.

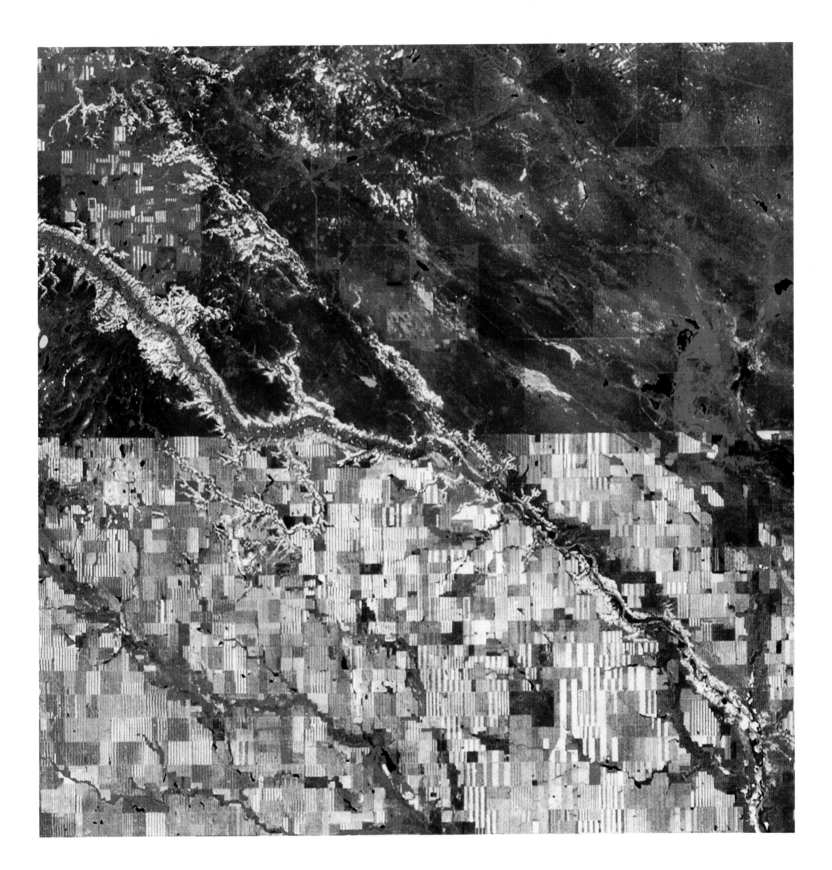

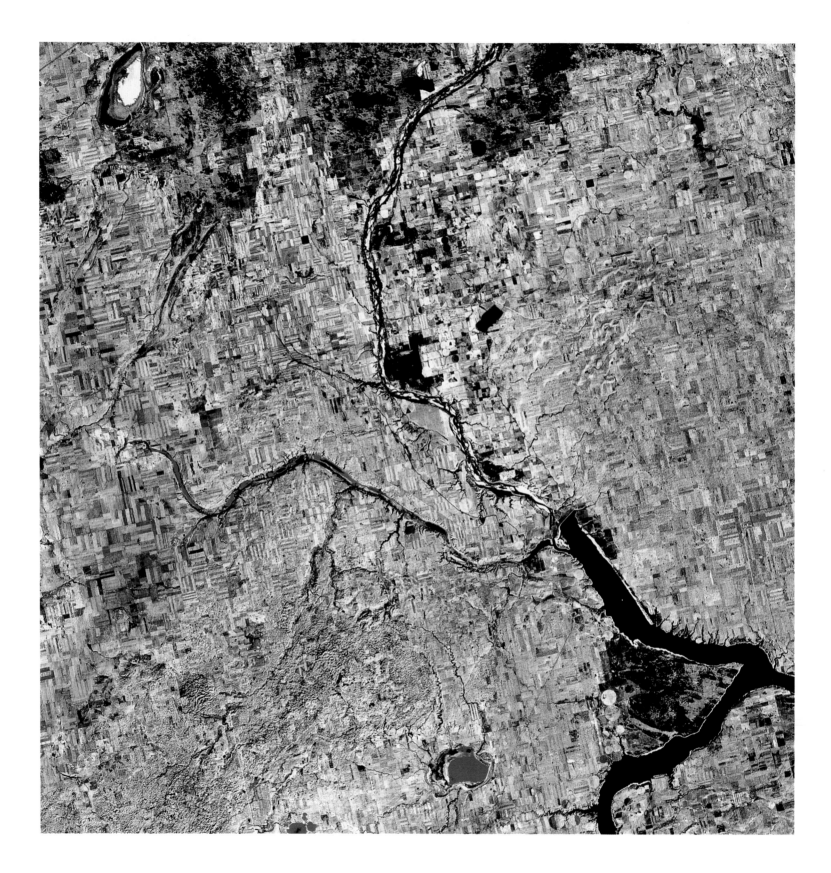

Early fall in the heart of the southern Saskatchewan prairie reveals an awesome spectacle of colour, putting to rest any notion that the region is either bland or homogeneous. Pictured are the lands around Lake Diefenbaker, created by damming the South Saskatchewan River halfway between Swift Current and Saskatoon. The multicoloured fields are produced by several factors: harvested crops, lands in fallow and different soils (the large deep blue patches indicate clay soil). The link between the Lake Diefenbaker reservoir and the surrounding farmland is vividly revealed by the circular patterns in fields close to its shores. Visible only from the air, these are artifacts of ''centre pivot'' irrigation systems—anchored in the middle of fields, huge sprinklers rotate on wheels like the hands of a clock. Elsewhere, the rough green patches are trees and scrub vegetation growing on nonarable outcrops of The Coteau, a long, low escarpment that runs southwest from here. The smaller image (right) shows the lake's hilly western shore.

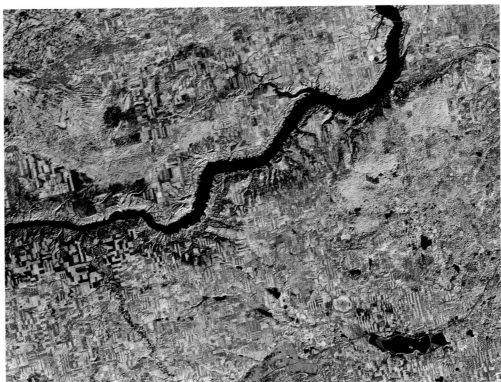

□ □

Myriad wetlands and dense black spruce, aspen, jack pine and tamarack forests are the only items on the topographical menu around northern Lake Winnipeg, right, and central Manitoba's interlake region. Like most of central and southern Manitoba, this largely uninhabited portion of the northeastern Great Plains was once entirely submerged under glacial Lake Agassiz. Since that massive lake's drainage and disappearance with the continental glaciers approximately 10,000 years ago, millions of migratory waterfowl have come to rely on the area's leftover lakes, pools and swampland for their spring and summer habitat.

Pressures on the waters shown here come mainly from people seeking recreation. Otherwise, the area's marginal climate and poor soil conditions have kept agriculture and other disruptive settlement to a minimum. Similar wetland sites farther south have been ploughed over or drained as a consequence of the ongoing consolidation of farm lots and fields and the spread of human settlement. That process has eliminated some bird species completely and forced many others to migrate beyond their traditional range in search of suitable conditions for nesting, feeding and rearing their young.

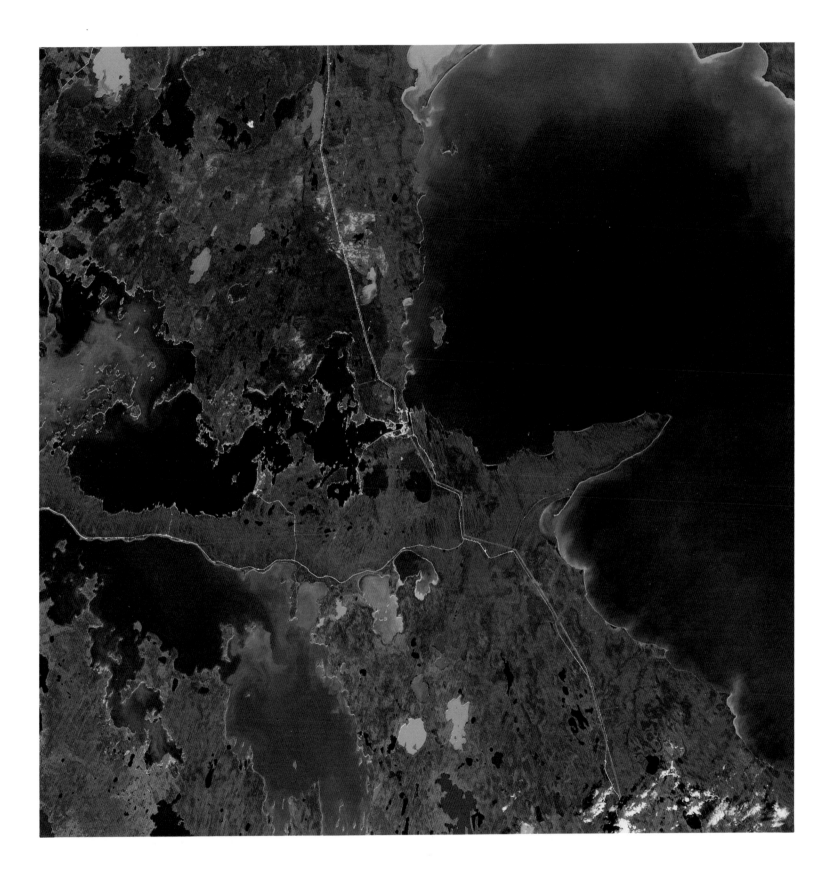

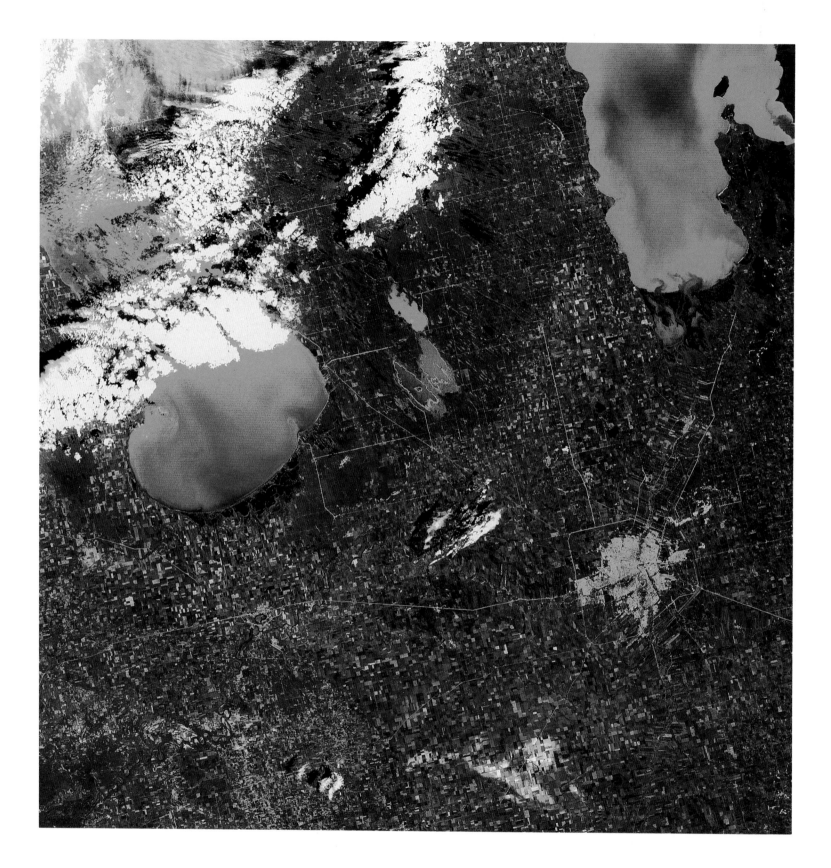

Like the spokes of a wheel, railroad lines and highways radiate outward from Winnipeg's circular blue-green mass, adding literal reinforcement to the city's reputation as a transportation hub and an important gateway between western and eastern Canada. Founded as Fort Rouge by French fur traders in 1738 at the confluence of the silt-laden Red and Assiniboine rivers (flowing from the south and west, respectively), Winnipeg first blossomed when the westward advance of the Canadian Pacific Railway hit town in 1881. Today, it is home to over 600,000 people—more than half of Manitoba's entire population.

As with the rest of the southern and central portions of the province, glacial Lake Agassiz left its indelible imprint on much of the landscape in this image as well. But where other parts of the province are marked by extinct shorelines, moraines and correspondingly rocky soils, the former lake bottom immediately south and west of Winnipeg is covered with thick layers of finer, richer sediment—the stuff of Red River Valley legends. The result is a parquetlike pattern of farmers' fields that, from the ground, conforms to the prototypical prairie scene of flat land and farms as far as the eye can see. In this mid-July image, healthy crops show up in varying shades of red. The only noticeable exception is an unusual pale green streak 20 to 30 kilometres long near the bottom of the scene, where it looks as though someone has used a giant eraser to delete the red vegetation. The reality is only slightly less bizarre: the streak is the scar left in the aftermath of a recent tornado.

The mottled green pattern that interrupts the red fields in the southwest is yet another Lake Agassiz relic—this time, exposed portions of an ancient delta. The assortment of sand, silt and gravel was laid down when a river as wide as the lower Mississippi once flowed across a part of the plains (creating the channel now followed by the much smaller Assiniboine River) before dumping its load as it emptied into the vast waters of Lake Agassiz. The ridge line that marks the edge of the Pembina Hills, the first in a series of low steps one encounters heading west across the prairies, is also visible as a faint red line cutting across the lower left-hand corner of the image.

□ □

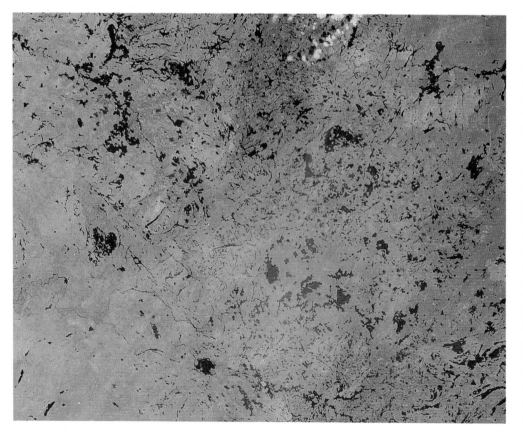

In an average year, more than 700,000 hectares of Canadian forests are destroyed by fire. This pair of images, obtained in July and August 1974, clearly shows how satellites can be used to monitor these dramatic events as they occur and to assess the extent of their impact—both during the fire and after the flames are put out.

In the first image (right), ominous plumes of thick, white smoke from at least half a dozen separate fires blow west out of northwestern Ontario and into eastern Manitoba (a small portion of Lake Winnipeg is visible in the lower left). Once the fires have been extinguished, the extent of the burned areas shows up vividly in the second image (left) as large green scars against the reddish brown colouring of normal, healthy vegetation. A quick comparison between the two images suggests that by the time the first was obtained, the bulk of the damage had already been done. Judging by the source area of the smoke, it also seems likely that the wind had just recently shifted and was by this time blowing the fire back on itself, where there would be little new fuel to sustain it.

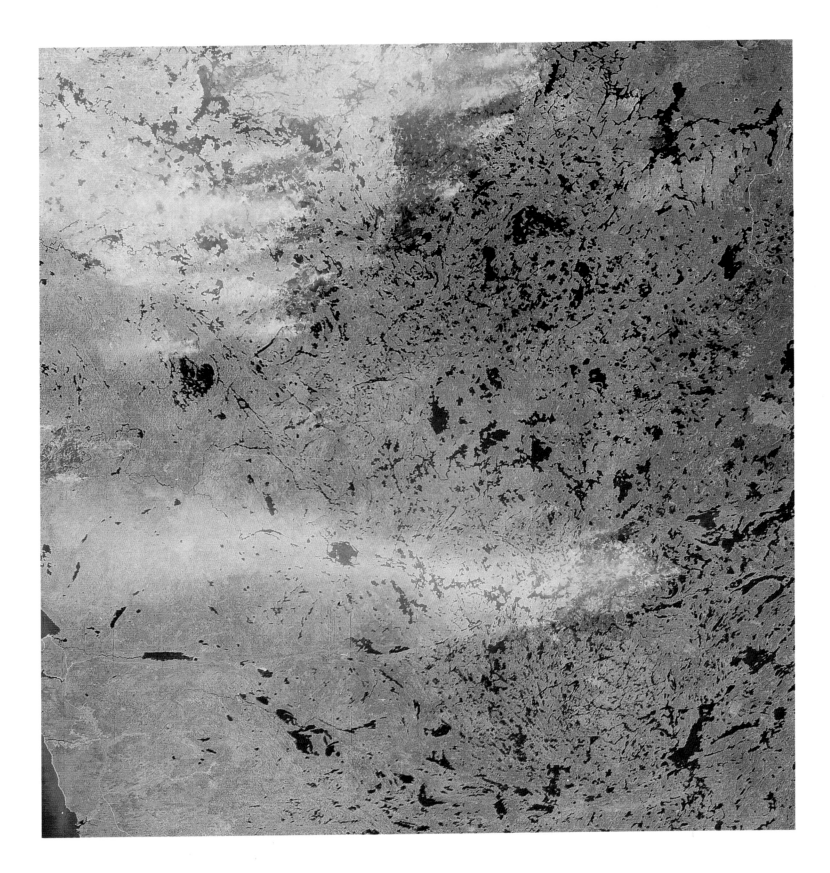

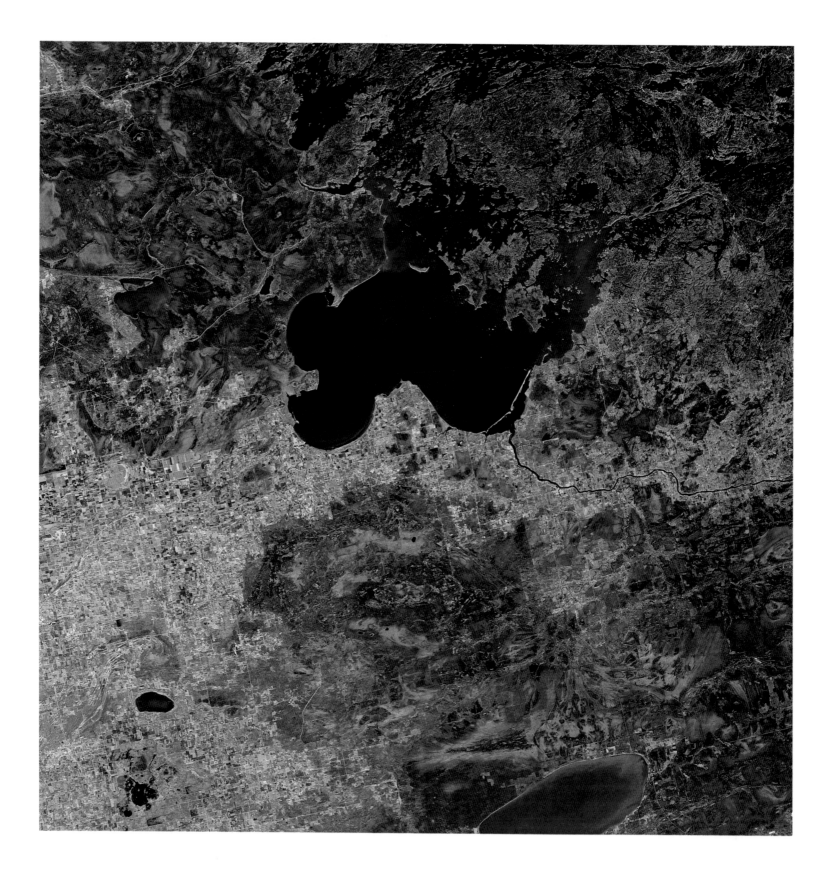

The melting retreat of the continental glaciers approximately 10,000 years ago sustained numerous huge pro-glacial lakes along the Canadian Shield's outer perimeter. The largest of these was Lake Agassiz. Equal in size to five or six Lake Superiors, it covered the lower half of present-day Manitoba, along with bits of Saskatchewan, Ontario, North Dakota and Minnesota. The portions of Ontario, Manitoba and Minnesota shown here adjoining Lake of the Woods were among the first to re-emerge once the ice had withdrawn and Lake Agassiz began to drain away.

The familiar bare rock and forests of the exposed Shield (Ontario), upper right, tell relatively little of this recent past. But in the southern and western portions of the image, Minnesota and Manitoba, the surface is precisely what one would expect of an old glacial lake bottom—a mixture of swamp, sand and assorted glacial debris. Ancient shorelines and moraines produce long, sinuous ridges that can be traced for hundreds of kilometres.

Agriculture in the area is restricted to well-drained portions of the lake bed and river valleys. In this late-September survey, square blue fields appear wherever crops have been harvested. The horizontal break in intensive agriculture on the left corresponds roughly with the Canadian/U.S. border. That boundary continues into Lake of the Woods at its southwest shore. After jogging north to catch a part of the lake, a peninsula and a few islands, it follows Rainy River east and off the image. At top left, fabled Highway One begins its journey westward across the prairies.

□ □

Heading east from the Pacific or west from the Atlantic, the midway point in any journey across Canada will always be Thunder Bay, lower middle. Hugging the shoreline of Lake Superior, yet sheltered from the open water by its large protected harbour, the city is an important transportation axis between west and east. Each year, the port of Thunder Bay moves twice as much domestic cargo as any other port in Canada. The bulk of this trade consists of huge shipments of grain from the prairies, as well as minerals, lumber and pulp and paper from western Canada or the adjacent Canadian Shield. The railroad lines and highways that help bring these goods to port can be seen converging on the city.

The bright red coloration surrounding the city indicates a few modest farms and the predominance of deciduous vegetation. The darker red-brown that covers the remainder of the image is produced by coniferous forest. Not only is the latter riddled with logging roads, but there are few areas that do not bear the telltale patterns of extensive clear-cutting. Active logging sites are bright blue, while those worked over in the past display various hues—from pink to grey to red-brown—depending on the degree of regeneration.

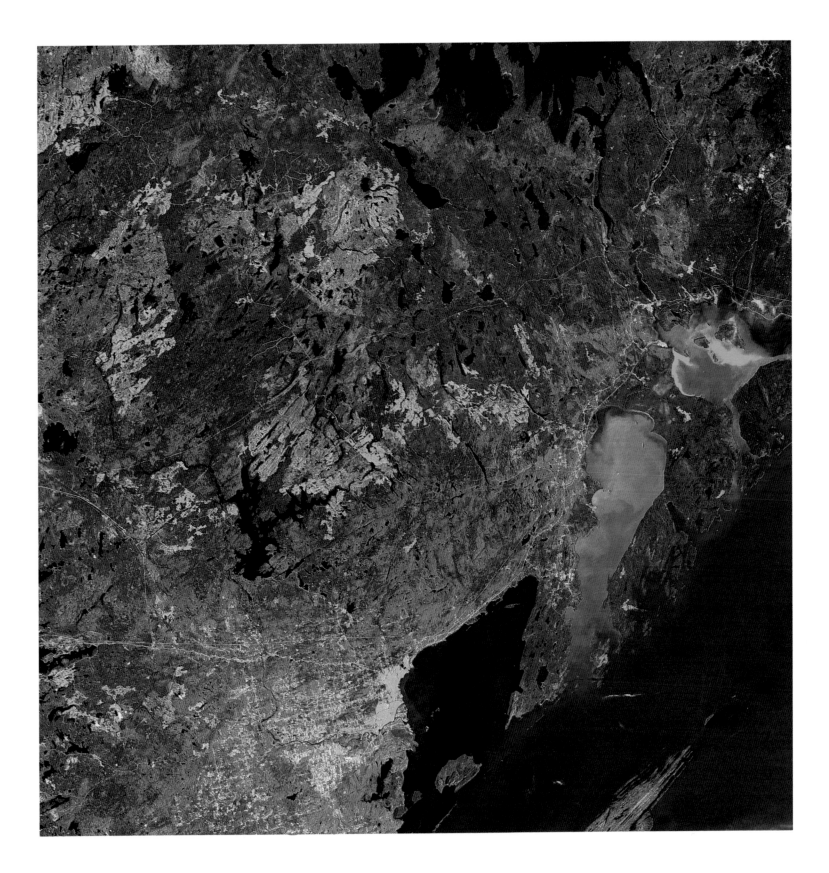

□ □

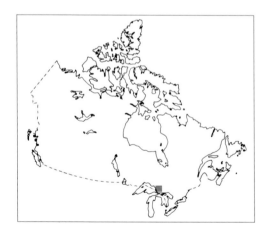

Looking more like isolated residential subdivisions than gaping holes in the ubiquitous red forest, scores of active logging sites dominate the rough Ontario landscape northeast of Lake Superior. Connected by a dense network of private access roads, the industrial clearings overshadow the string of communities whose names are normally associated with the area: White River, upper left, Chapleau, far right, and Wawa, the latter showing as a small blue square a few kilometres inland from Superior's sharp-cornered shoreline. (Immediately to the north of Wawa and many times its size is a blue patch of open ground where sulphur emissions from an iron-sintering plant have killed all the natural vegetation.)

Long a focal point for native trade to the interior and along the majestic Superior shore, the Wawa area has also been a point of European contact since the early 1700s. For a time, it was the site of a French trading post called Michipicoten—the name that still identifies the large island under wispy cloud cover, at lower left, as well as one of the innumerable cascading rivers coursing down the Precambrian Shield to the great lake's rocky north shore. Another river barely discernible on the left edge of the image is the Pukaskwa, which also gives its name to the 1,900-square-kilometre national park just out of view to the west.

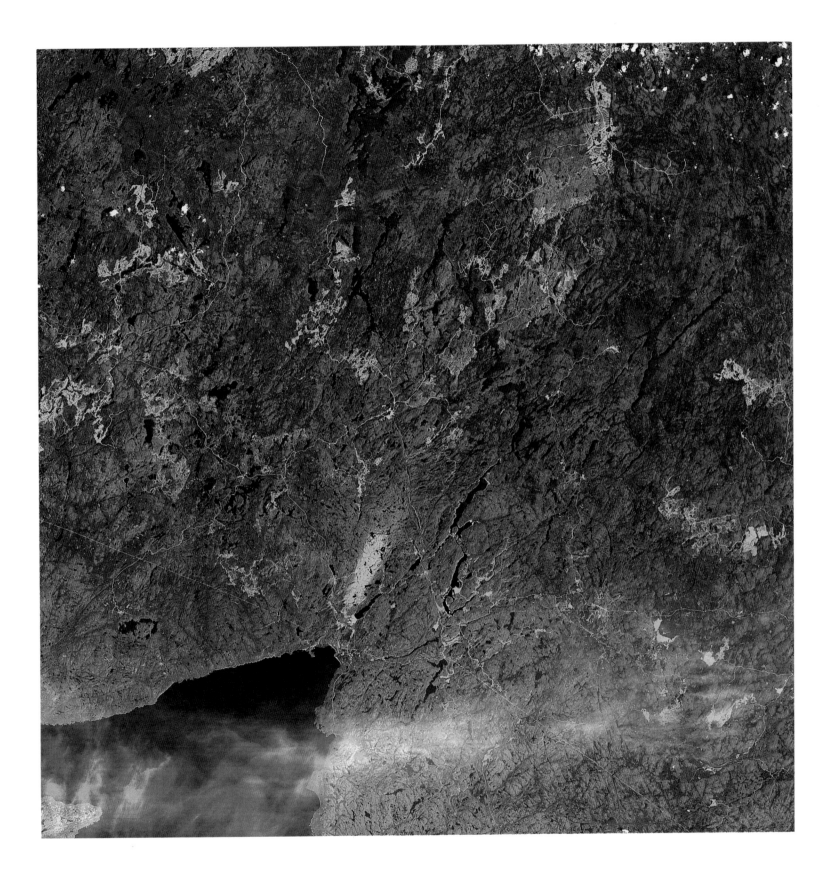

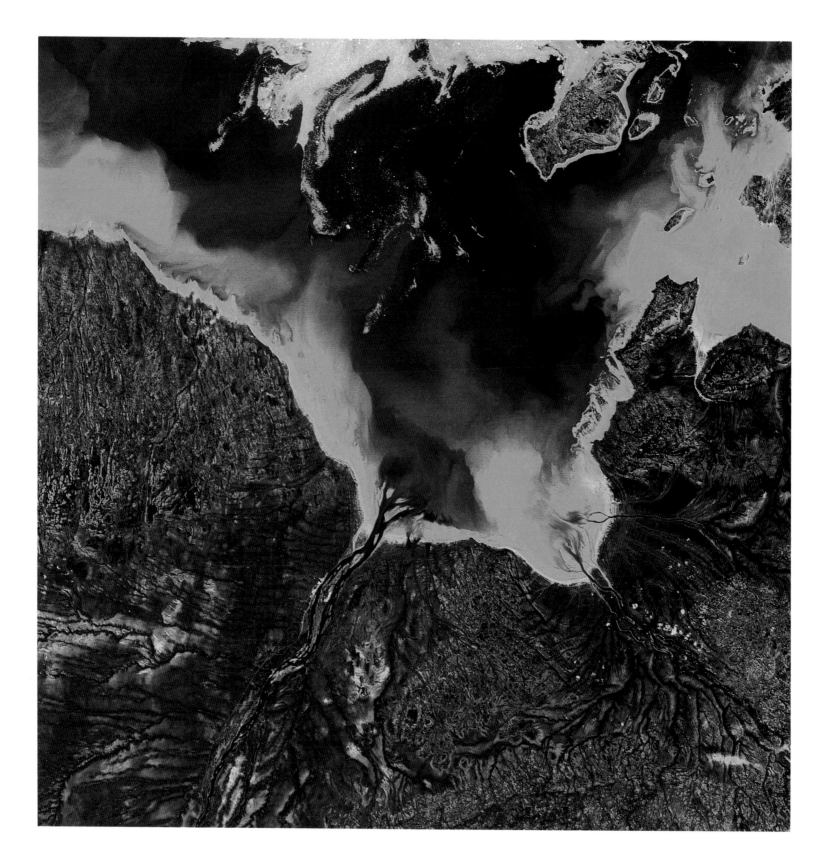

Swirling sediment from nearby clay plains pours out of the swampy Hudson Bay lowlands into southern James Bay. Five to seven thousand years ago, much of this lowland was still submerged beneath the waters of the Tyrrell Sea, which flooded the area after the last continental glaciers retreated north. The clay plains, the countless rivers and the complicated drainage system here today are all a legacy of that earlier pro-glacial era.

Despite its relatively recent emergence, the area has long played an important role in Canadian cultural history. The many rivers provided access to the rich interior for various native peoples hundreds of years before the arrival of English traders in the 1600s. At that time, Rupert Bay, the sediment-laden body in the upper right-hand corner, became the site of the Hudson's Bay Company's first trading post (Rupert House, 1668). Four years later, on one of the many small islands near the mouth of Moose River, at centre left, the second trading post was established at Moose Factory. Still visible today, it is recognized as Ontario's first English settlement. Along the west shore of Moose River, next to Moose Factory, is the town of Moosonee, Ontario's only saltwater port and the northern terminus of the Polar Bear Express railroad.

To the north, pack ice clings to the shore of Charlton Island, at top right. Ice floes are also evident throughout James Bay, even though it is mid-June.

□ □

Looping and swirling in the chilly waters of southeastern Hudson Bay like strands of a necklace or something squeezed out of a tube, the Northwest Territories' Belcher Islands are the last lonely outcrops of one of the Canadian Shield's ancient mountain ranges. Even the Shield's hardest, oldest rocks were once molten and malleable; they came to their present state after the last continental ice sheets melted, ocean levels rose and the northern interior of the continent was flooded by the sea. For a time in between (perhaps several thousand years), they were completely submerged, as much of the land in eastern Canada took time to rebound from the tremendous downward pressure produced by the weight of the glaciers.

With that rebounding process still under way, it is possible that the Belcher Islands will be further enlarged in the millennia to come. Whether it takes 5,000 years or another 500 million, the principle applies equally to all landscapes: no matter how durable or permanent things appear to be, our present glimpse is but a snapshot drawn from an unending process of destruction and renewal.

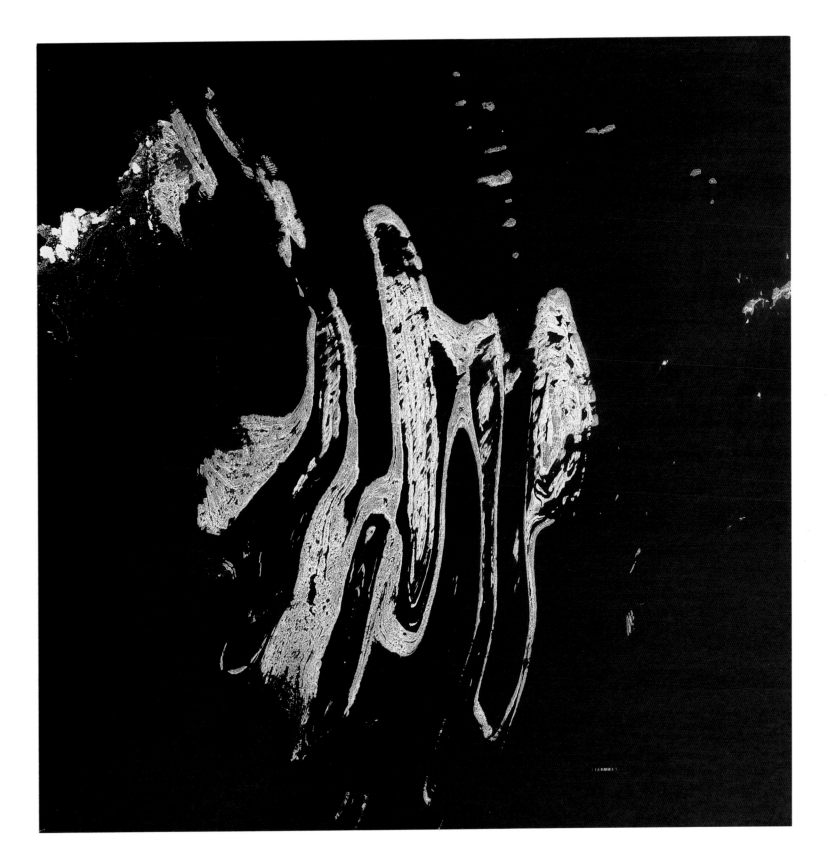

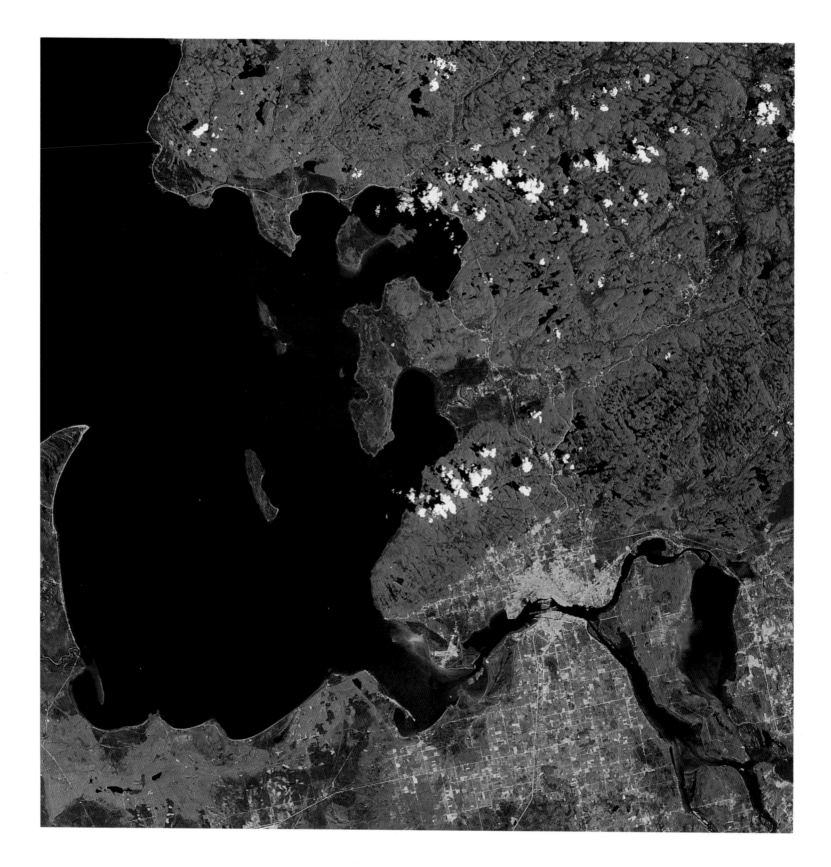

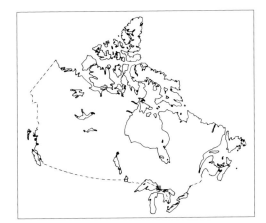

Two cities with the same name—Sault Ste. Marie, Ontario, and Sault Ste. Marie, Michigan—face each other across the St. Marys River as it flows out of Lake Superior and on toward Lake Huron. Between them, the river makes an eight-metre descent through rapids that would be impassable to all water traffic were it not for two canals (one in Canadian waters, the other in American) constructed here in the latter half of the 19th century. The urban buildup, which shows as blue, reveals that Sault Ste. Marie, Ontario, is by far the larger of the two cities. Unlike its counterpart to the south,

which is mainly a lumber and tourist town, the Canadian city is also an important steel-making centre and a major port and otherwise plays a dominant role in all aspects of the region's economic, political and social activities.

While agriculture has a place in the rolling lowlands south of the river, farming is precluded to the north by the emergence of the Canadian Shield. Its rocky contours are covered with numerous small lakes and dense forest, highlighted in bright red. The white popcornlike puffs are cumulus clouds, while the Trans-Canada Highway is

clearly visible as a thin blue line snaking its way north out over the Shield, hooking up with the Superior shoreline at the south end of Batchawana Bay.

The blue-green patches along both sides of Superior's shore indicate low-lying swamps and bogs and exposed deposits of silt and sand. As for the Canadian/U.S. border, it divides Lake Superior and the western end of the St. Marys equally, then continues east along the north channel, around the top of Sugar Island, before swinging back down through the middle channel and out of the image to the south.

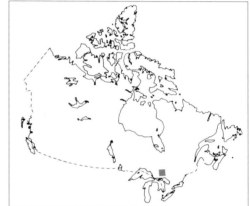

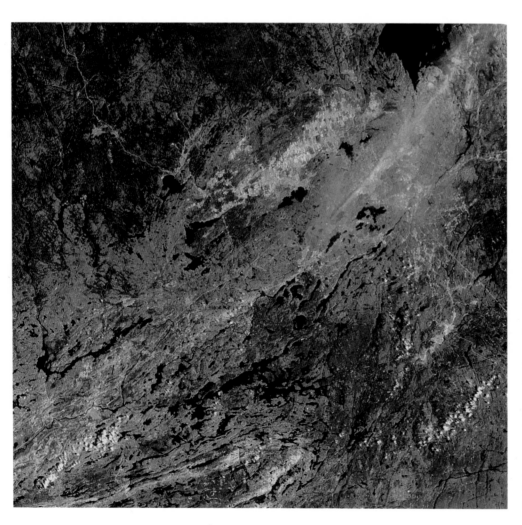

These images of the Sudbury Basin say as much about the technological progression from the first Landsat satellite to the latest as they do about the vast, rugged expanse of the Canadian Shield. In the Landsat 2 image taken in 1977 (left) the lower spatial and spectral resolution coupled with higher distortion produces a relatively murky view compared with the one obtained from Landsat 5 in 1984 (right). On the latter, it is much easier to spot the semicircular scar of the meteor crater defining the basin's northern boundary. Other details, such as the communities of Sudbury and Espanola (the purple blotches along the bottom), backcountry copper and nickel mines, active logging sites (marked by the pink area, centre left) and the linear erosion of the ancient Shield, all come sharply into view.

Yet what the earlier image lacks in realism and detail, it makes up for in raw, impressionistic zeal: imagine a Group of Seven canvas from space. Geologic and cultural specifics are harder to extract at a glance, but a powerful sense of the age and wild durability of the landscape comes through in their place. In its own way, this blue-red image reveals much about the rough and abused landscape—epitomized by the foggy blue smear at upper right that marks the exhaust plume from Inco's giant smokestack.

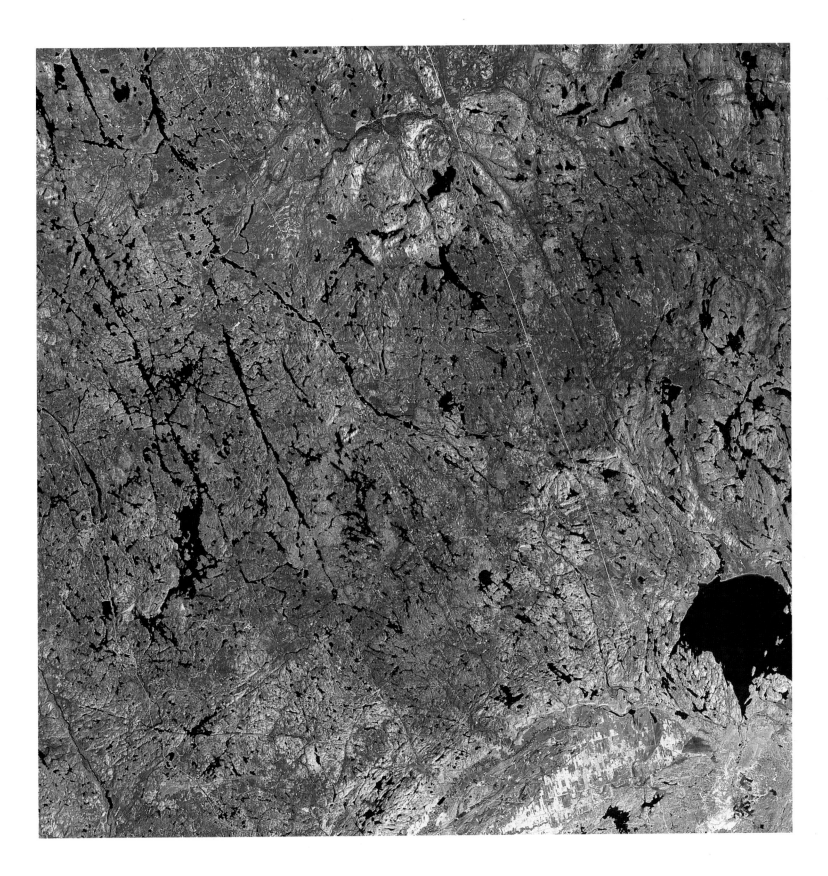

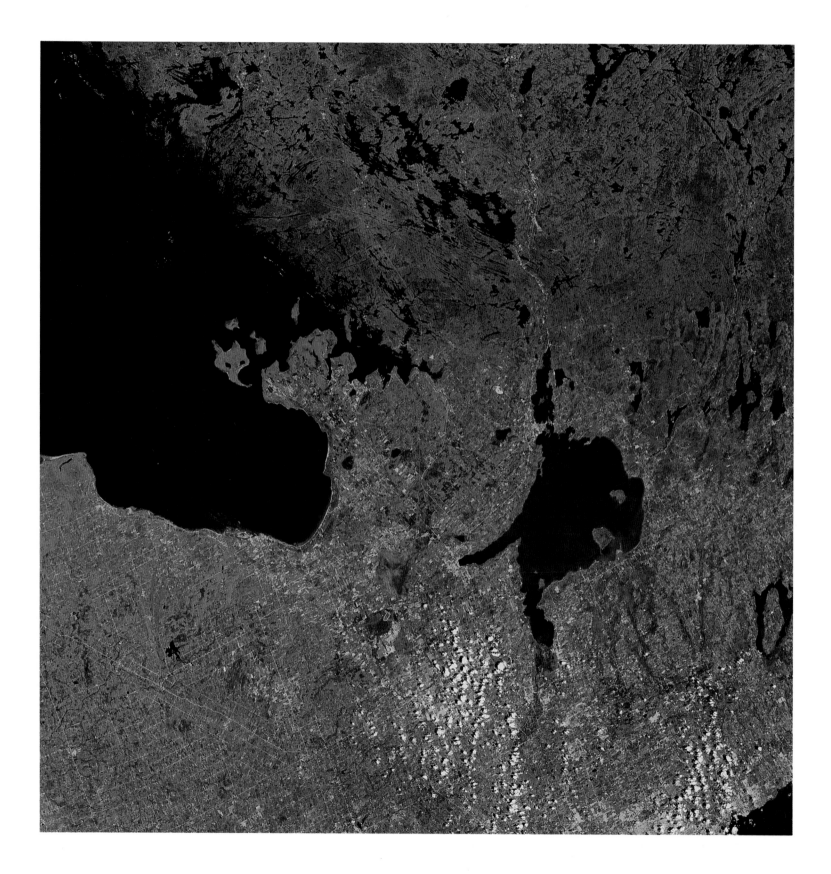

□ □

To the millions of people living in Metropolitan Toronto and other adjacent communities along Lake Ontario, bottom right, most of the area revealed on this image has only one real moniker: cottage country. Beginning with Georgian Bay, left, and Lake Simcoe, centre, and continuing north through countless other smaller lakes and rivers, there is hardly a shoreline anywhere that is not the site for some city dweller's holiday-weekend retreat.

Upon closer inspection, however, it is easy to see that this portion of south-central Ontario can actually be divided into two distinct regions. The boundary line runs across the image horizontally, from the densely forested (bright red) islands off the southeast shore of Georgian Bay to a point just above the cluster of medium-sized lakes on the right-hand side of the image. To the north of this line is the exposed Canadian Shield, while to the south, one finds the oldest, outermost reaches of the continent's central sedimentary lowland. Besides being much flatter, the southern region is also covered with layers of sand and gravel deposited by glaciers during the last ice age. The movement of the glaciers also explains why all of the lakes in this area are aligned on the same northeast-southwest axis.

In cottagers' parlance, the lake region immediately south of the boundary is called the Kawarthas, while areas to the north are part of either Muskoka or Haliburton townships. Lake Muskoka, at upper centre, is the first large lake encountered north of the boundary. That it and others nearby have a different character than the lakes in the south is made clear by comparing the smooth southern shore of Georgian Bay with its rocky, variegated counterpart to the northeast.

Bounded by Lake Huron, top left, Lake Erie, lower right, Lake St. Clair and the St. Clair River, lower left, southwestern Ontario's vast triangular territory is one of the richest and largest uninterrupted stretches of prime agricultural land found anywhere in North America. A dizzying sea of green, red, pink and blue fields reflects a diverse assortment of crops, including corn, beans, tobacco, wheat and other grains, as well as pasture for livestock. From such a perspective, it is almost inconceivable that as recently as 200 years ago, most of this gently rolling land was covered by dense forest. Yet extensive cutting and clearing began only after the American War of Independence, which prompted the migration of thousands of Loyalist settlers from the Thirteen Colonies into these more northerly British lands. In the process of turning the forests into fields, the settlers also established most of the inland towns and cities (dark blue clusters) that dominate the region today. The largest visible here are Kitchener-Waterloo, far right, and London, centre.

The clearance of the southern Ontario forests also laid bare the extensive land-scaping work performed by the last continental glaciers before their retreat approximately 10,000 years ago. The predominantly pink-coloured fields around Lake Huron and the St. Clair River are indicative of glacially deposited clay plains. In the northeast, these same ice sheets left a more unconsolidated foundation of silt, sand and gravel, while along the north shore of Lake Erie, sandy soil is the norm. Although few are detectable from this height, beaches and shorelines from old glacial lakes are present as low ridges and hills, particularly in the vicinity of the present Lake Huron shoreline.

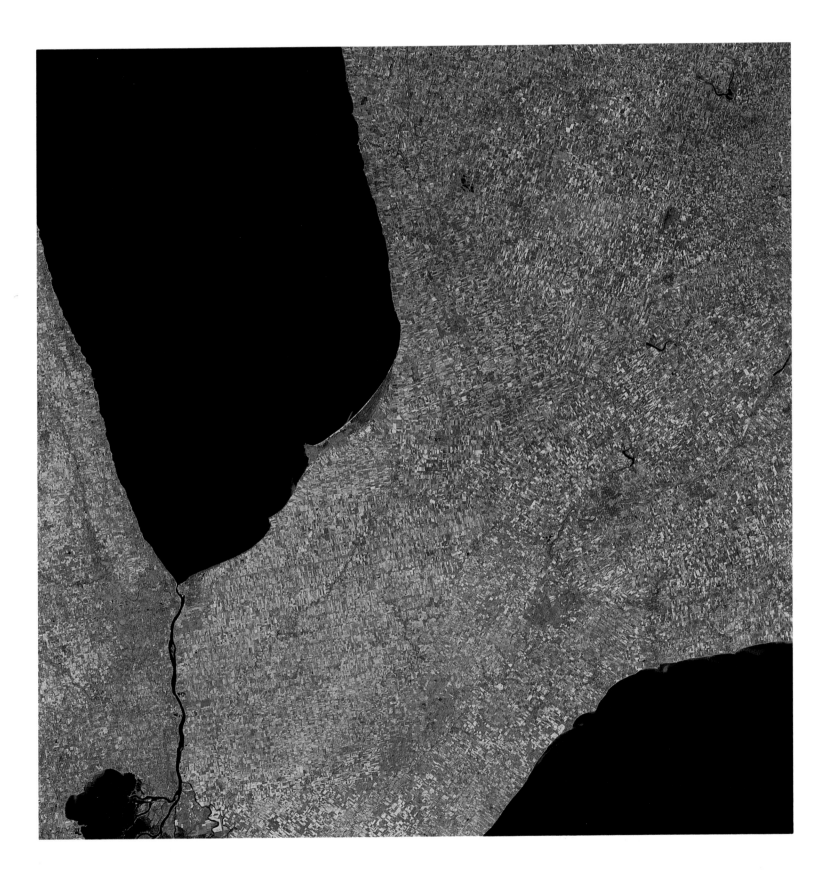

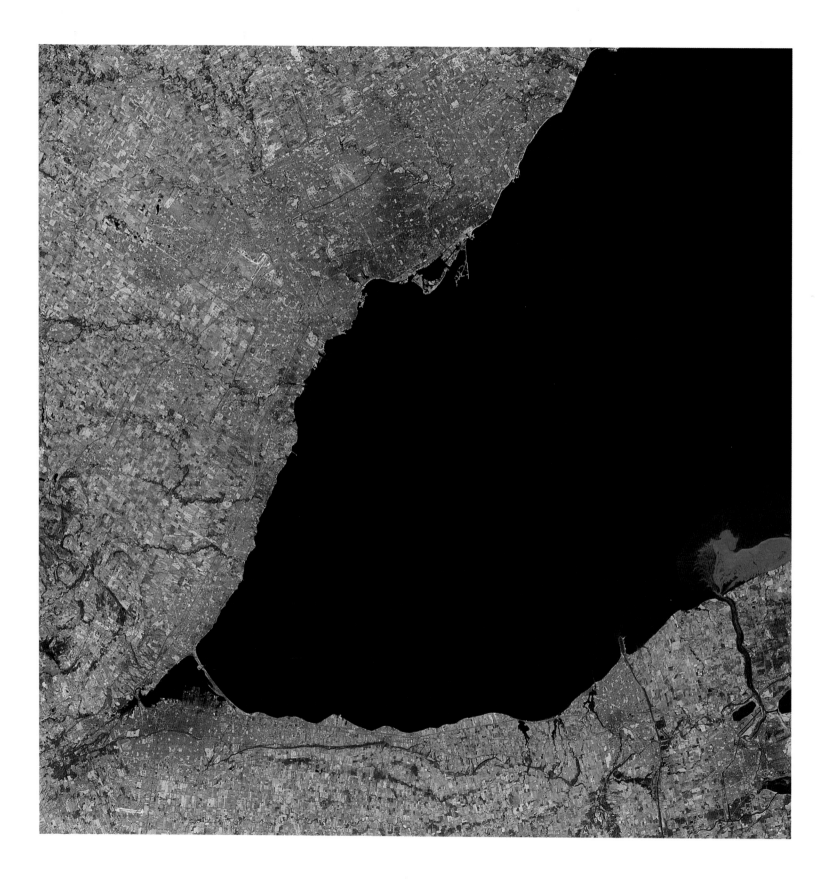

Close to five million people—nearly 20 percent of Canada's total population—live in the area recorded in this single image taken over western Lake Ontario. As the economic, political and cultural focus for the region, Metropolitan Toronto is clearly visible at upper centre, where the dull blue tones of urban buildup along the lake intensify as they spread inland. The distinctive configurations of the Toronto Islands, the city's large natural harbour and the human-made tentacles of the Leslie Street Spit define its waterfront. In this late-April scene, the most recognizable feature might be the city's many golf courses, which show up as vivid green clusters in and around the blue sprawl.

The land northwest and west of Toronto, beyond the massive runways of the international airport, is still alive with the pink and green of agriculture and natural land use. This is Canada's most fertile and—thanks to the proximity of Toronto—most expensive farmland.

Hamilton, the region's second largest city, lies at the southwest end of the lake. There, the Burlington Skyway Bridge marks the outer perimeter of Hamilton Harbour, site of the city's huge waterfront steel mills (the intense heat from the open furnaces shows up here as tiny red dots). Along the southern shore of the lake to the east, the twin piers at the head of the Welland Canal extend northward into the lake at St. Catharines. Still farther east, milky blue sediment from the Niagara River is captured by Lake Ontario's invisible long-shore currents and carried out of sight to the right. Niagara's famous 60-metre cataract is situated in the extreme lower right-hand corner of the image, where the river narrows and turns from deep to light blue.

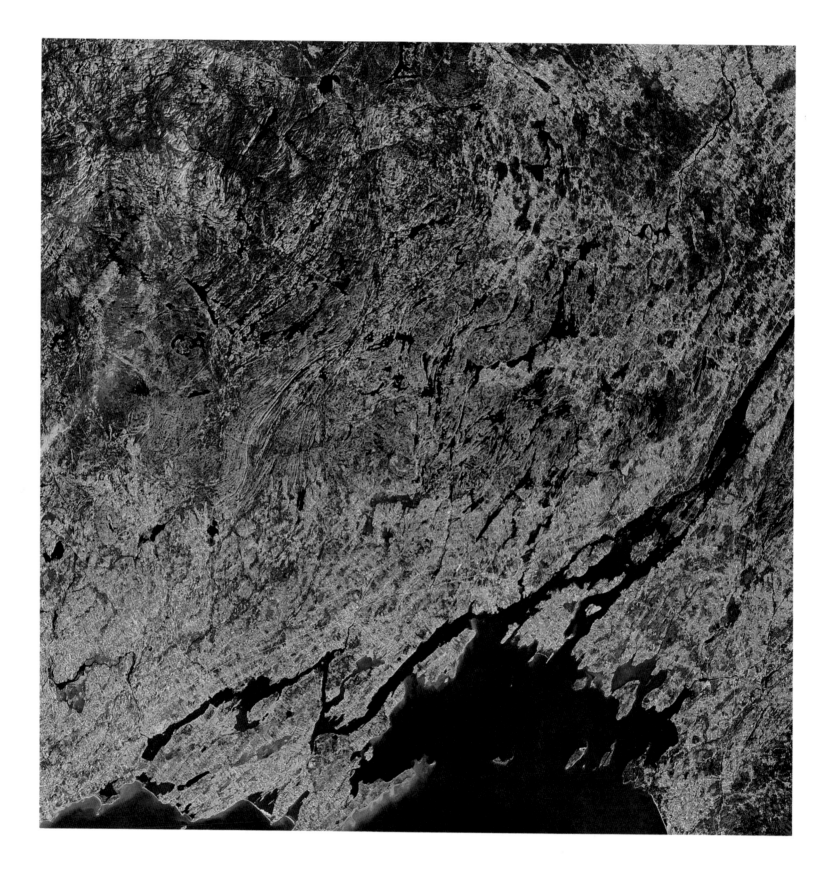

The gnarled, rugged and rocky Canadian Shield is a constant presence in the Great Lakes all the way from Superior to Ontario. But it is only when the vital waters exit eastern Lake Ontario at the St. Lawrence River that they finally face the Shield head-on. The conflict occurs over a 50-kilometre stretch of the upper St. Lawrence called the Thousand Islands, revealed here as innumerable brown specks, centre right, against the deep blue water. The islands are, of course, resistant fragments of the same exposed Shield that underlies the dark green forests running across the up-

per two-thirds of this image and carries on south of the river into upper New York State to form the Adirondack Mountains.

The boundaries between the exposed Shield and the younger sedimentary lowlands elsewhere on the image are easily seen in the transition from forests to field crops. In this early-October scene, the blue squares in the Ottawa Valley, top, and on the north shore of Lake Ontario represent harvested fields, while the red patches indicate farms where healthy vegetation is still in the ground. Although they do not stand out too boldly, several blue clusters along

the Canadian side of the water are actually cities and towns. Kingston, the largest, is located just south of centre.

If the hard, resistant Thousand Islands represent one extreme, the much larger farmed-over peninsula jutting far into Lake Ontario in the lower left represents the other. Built largely of sand and sediment piled up and washed ashore by the lake's long-shore currents, the dune-laced promontory known as Prince Edward County is home to no fewer than four provincial parks. In this image, shifting sands along its shores show up as light blue.

Some define the Ottawa Valley by the local dialect, others by its history as the onetime principal water route from eastern Canada to the upper Great Lakes and the interior beyond. But in this view from space, it shows itself best as a red and blue patchwork of farmers' fields and pastures. Together, they mark the extent of the valley floor, from its narrow beginnings at Pembroke and Petawawa, far left, to the broader expanse of Ottawa-Carleton, Leeds and Grenville, and Stormont, Dundas and Glengarry counties, far right. Ten thousand

years ago, these lower, wider reaches were submerged by the Champlain Sea, a narrow arm of the Atlantic Ocean that extended inland along what is now the St. Lawrence Valley. When the continental glaciers melted, the sea withdrew, leaving behind a complicated mixture of low drumlins, glacial till and swampy lowlands. One such swamp shows up in this image as a brown smear just to the right of the city of Ottawa—the solid blue mass centred around the confluence of the Rideau, Gatineau and Ottawa rivers, centre right.

Elsewhere, the image is dominated by the rough, forested terrain of the Canadian Shield, which shows up as varying shades of green (coniferous trees are darker than deciduous) on both the Québec, top, and Ontario, bottom, sides of the Ottawa River. Before it was made the national capital in 1857, Ottawa (then called Bytown) rose to prominence as a major lumber centre on the strength of trees culled from the nearby forests. Today, the Shield's woodlands, lakes and hills are prized more for their year-round recreational value.

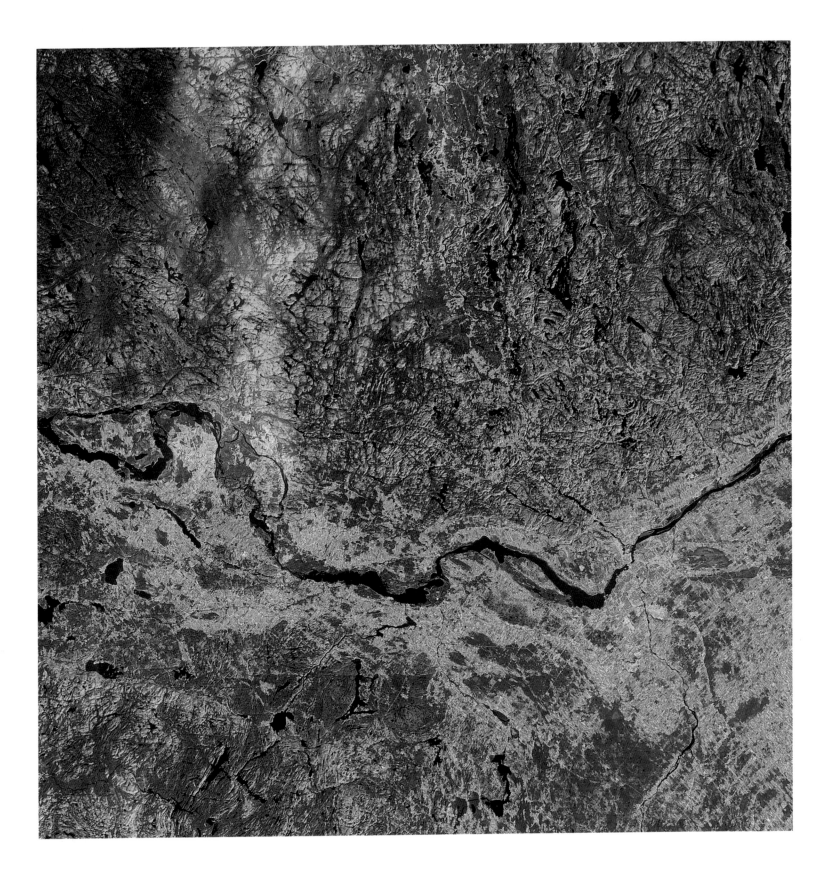

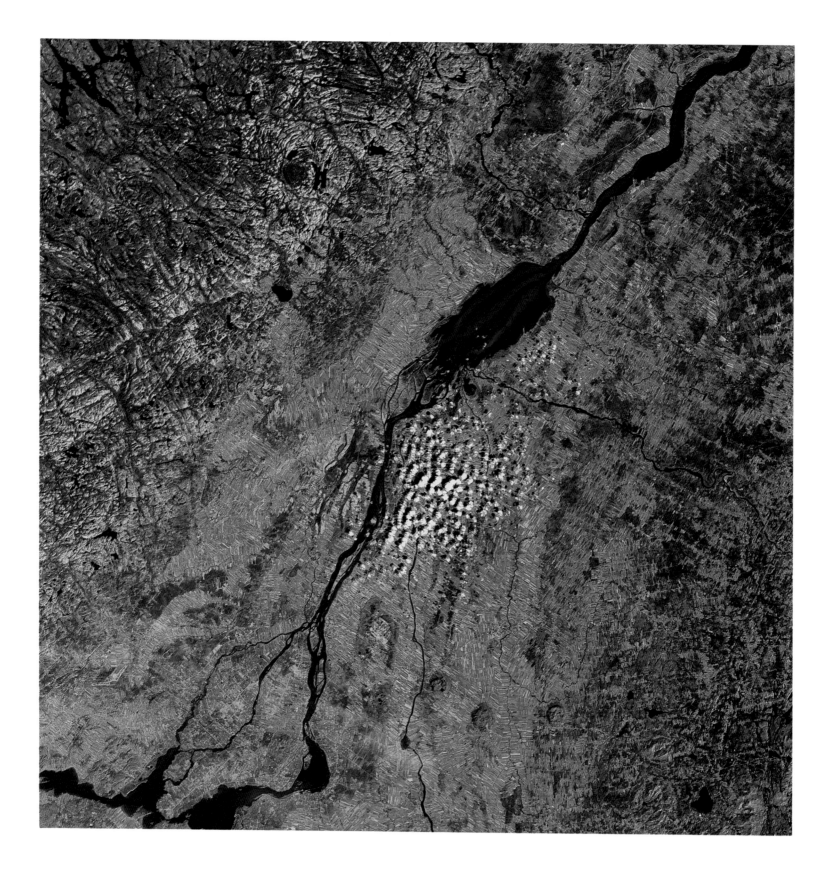

Two perspectives show Montréal, one of Canada's oldest cities (founded in 1642) and the world's second largest French-speaking centre, as it spills over its familiar island site into the surrounding St. Lawrence Valley mainland. The close-up (right) provides a clear view of main streets, highways and bridges spanning the river; the forested slopes of Mount Royal (the small red knob in the middle of the city); and runways at the region's two airports, Dorval (on the island) and Mirabel (on the left edge of the valley floor). The longer view (left) points out Montréal's strategic location at the confluence of the Ottawa and St. Lawrence rivers, in the heart of the fertile St. Lawrence Valley lowland.

The distinctive long, narrow fields appear as tens of thousands of tiny matchsticks over the entire area and are a 300-year-old legacy of Québec's original seigneurial land-grant system. Similar survey patterns persist elsewhere in North America (around Detroit and New Orleans, for example), wherever French colonists were the first Europeans to settle.

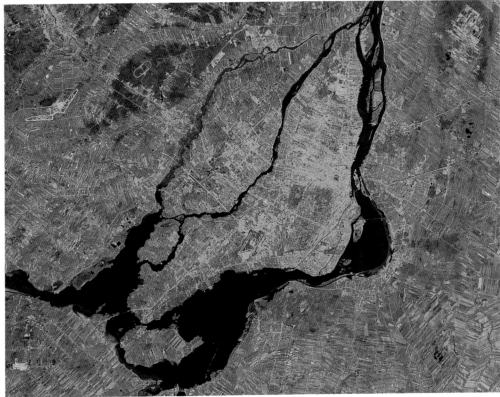

□ □

The focus of French settlement and culture in North America since it was founded in 1608 by Samuel de Champlain, Quēbec City once guarded the narrow opening to the upper St. Lawrence with its fortresses and cannons. Now a blue urban sprawl with more than half a million inhabitants, it rules the passage by the sheer force of its presence. As the provincial capital, its influence also extends well beyond the shores of the St. Lawrence pictured here.

Acting as a counterbalance to this dominance is Île d'Orlēans, the massive island opposite the city that divides the St. Lawrence into two separate channels for a distance of more than 30 kilometres. An important agricultural settlement since the early days of Quēbec, it still bears the familiar long-lot field patterns that have been passed down from the days of the seigneurial land-grant system. While this continuity is hardly remarkable in the more distant farms and fields up and down the valley, its persistence here seems slightly out of place. And in all likelihood, the patterns might well have changed were it not for the fact that 20 years ago, the entire island was designated a historical district.

In this midsummer image, the Laurentian Mountains to the north of the city show up in varying shades of green, indicative of the mixed forests that cover their hillsides. Where the hills meet the north shore of the St. Lawrence near the top of the image, it is easy to pick out the ski runs on Mont Ste-Anne. To the south of the river, a narrow band of farmland along the shore quickly gives way to the lower, forested hills of the Appalachian Mountains.

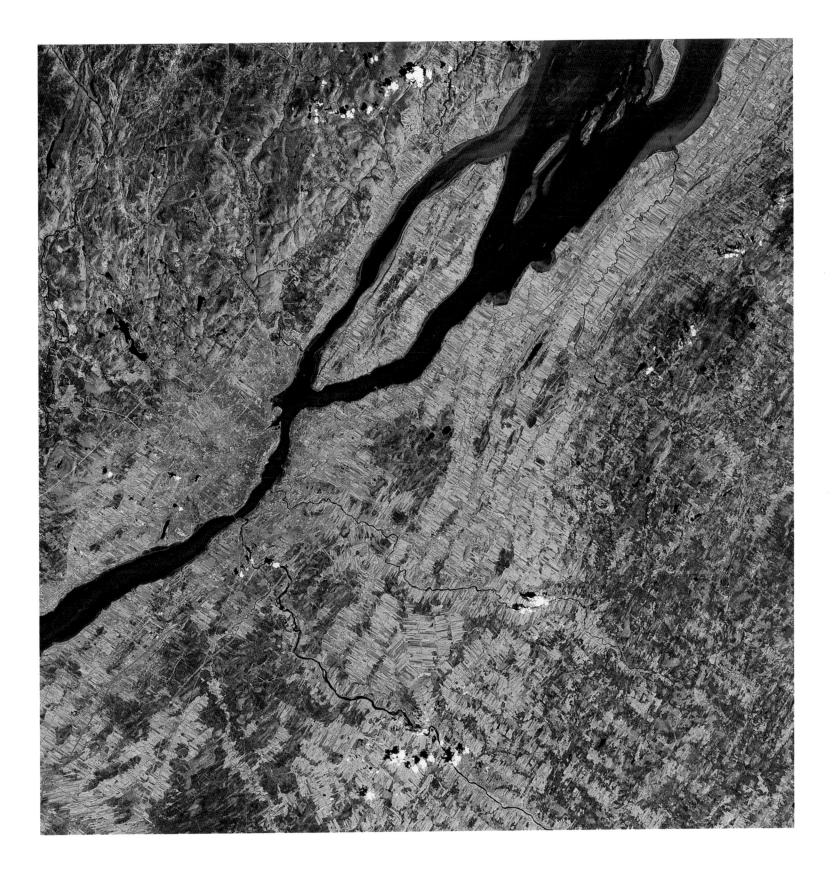

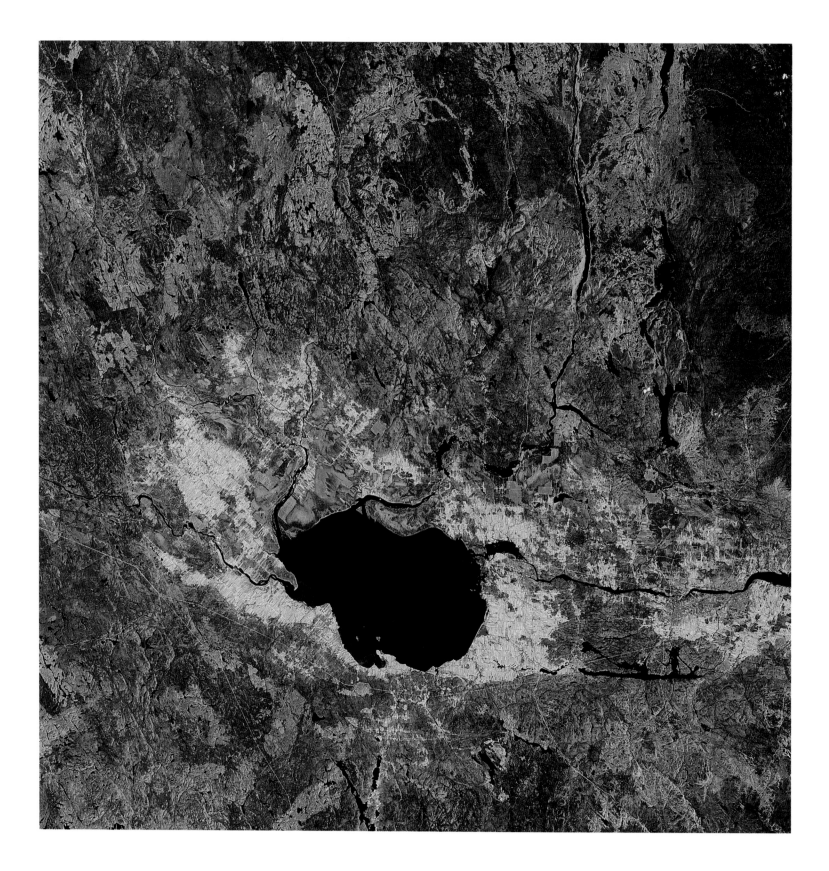

In the vast, largely uninhabited interior of Québec, the Saguenay River/Lac St-Jean region has stood out as a dramatic exception for centuries. A popular native trade route, a base for European fur traders as early as 1600, a pulp-and-paper centre by the late 1800s, a 20th-century setting for large hydroelectric and aluminum-smelting operations and now a popular destination for tourists, this large lake and spectacular gorge (with cliffs rising a few hundred metres above the water) have seen it all.

This activity has been enough to sustain a string of communities (which show up as deep blue) along the river and at several points around the lake. The largest of these is the combined mass of Chicoutimi and Jonquière, lower right. In addition to its urban population, the area also supports a small number of farmers who work the fertile plains, seen as yellow, between the lake and the surrounding rocky hills. Many of the farms contribute to a blueberry crop that reaches 4.5 million kilograms a year. Elsewhere, the lighter blue patches interspersed with the fields indicate swampy ground, while the numerous magenta cutouts are active logging sites.

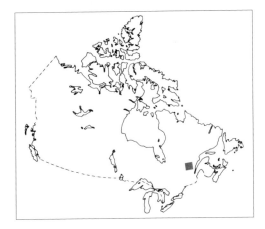

MANICOUAGAN RÉSERVOIR, QUÉBEC

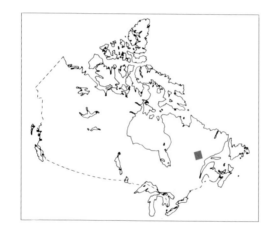

Formed in the span of a few violent hours after a meteorite collided with Earth 214 million years ago, the Manicouagan impact structure, at lower right, is the second largest and one of the best preserved of about two dozen known meteor craters in Canada. At ground level, this 65-kilometre-wide scar presents a relatively unspectacular 5-to-10-kilometre-wide trough of water ringing a 500-metre peak of melted, fragmented Canadian Shield. From the air, however, it is a stirring reminder of our planet's early history and of its relationship to other bodies in the solar system.

Scientists estimate that the energy released at the time of impact was equivalent to an explosion of 23 million megatons of TNT (150,000 times as powerful as the Hiroshima atomic bomb). As molten rock rushed into the crater, followed by collapsing rock around the rim, tremendous pressures caused the central mound to emerge. Today, the lake that surrounds it is used as a reservoir for hydroelectric dams to the south, on the Manicouagan River. The pink shading along the water's edge indicates sand and gravel beaches.

The large scar immediately west of the reservoir outlines the extent of a past forest fire. The yellow areas are new deciduous growth, while the pinkish red areas denote coniferous trees. A smaller, deep red patch to the northwest on the shores of Lac Plétipi is the result of a more recent blaze. To the right of the reservoir, a blue-grey service road can be seen tracing its way northeast to the yellow-green of new growth on a clear-cut forest and the dark pink tailings ponds of a mine site near the town of Gagnon (light pink). Blue-white areas in the upper left signal the widespread presence of reticulated peat bogs.

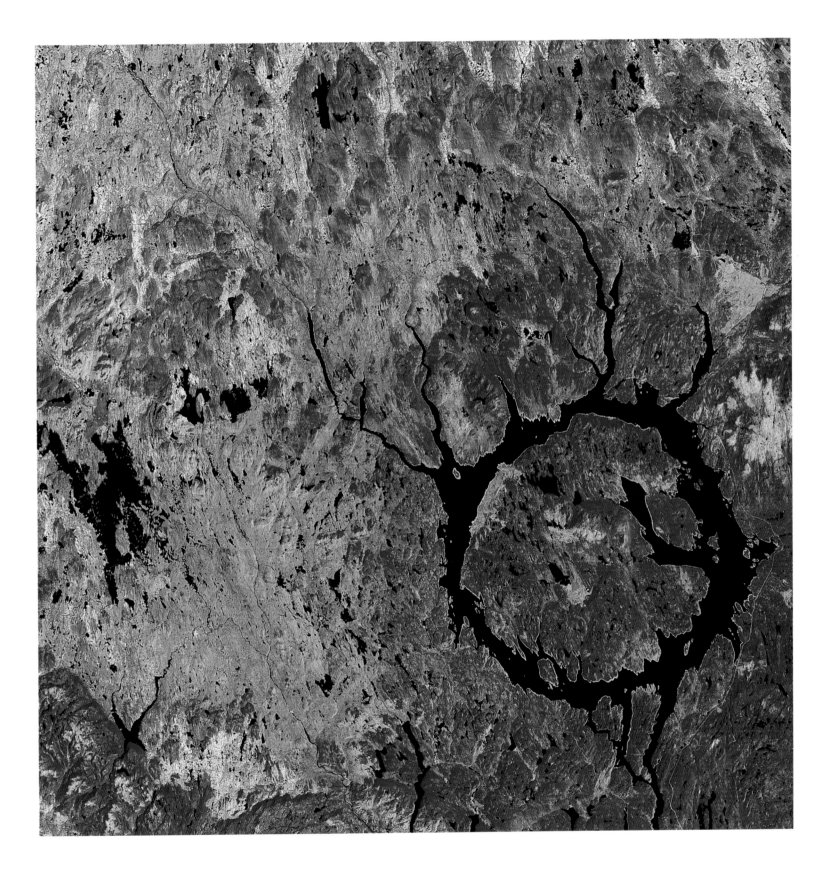

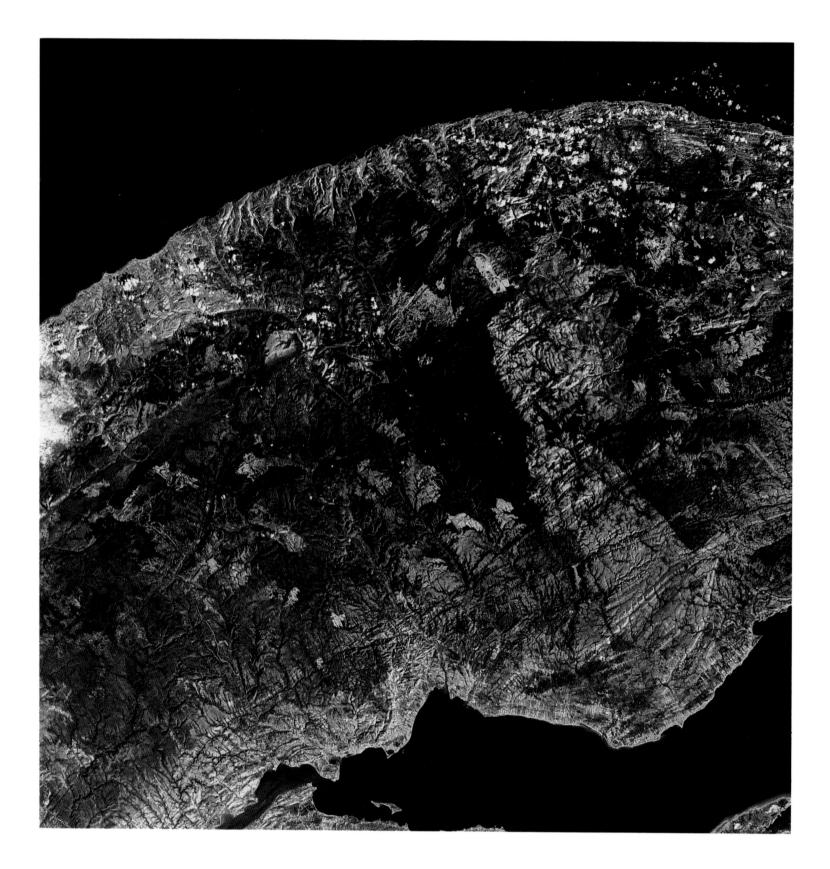

The name Gaspé derives from the Micmac word meaning "land's end." Yet when Jacques Cartier landed in Gaspé Bay, upper right, in 1534, it marked a beginning for what was to become Canada. In the intervening 333 years before Confederation, this rugged, rocky peninsula hosted successive inhabitations of French, British and American fisheries. Although some of their small coastal settlements persist, the Gaspé remains one of southern Canada's least populated regions.

Trapping, logging and recreation continue to draw people to Gaspé's mountainous interior. Composed of two separate ranges, the Chics-Chocs and the Notre Dame, the entire peninsula is actually part of the same 400-million-year-old Appalachian chain that rises out of Alabama in the south and continues all the way north to Newfoundland (interrupted by the Gulf of St. Lawrence). The only area of the Gaspé suitable for agriculture is the narrow coastal plain on the south shore, indicated here by the orange and blue stripes next to Chaleur Bay, bottom right. Logging is marked by blue-veined patches in the dark brown interior, the latter a colour that represents deciduous forests after their leaves have fallen in autumn.

Pulp-and-paper operations in the town of Bathurst, top centre, colour the landscape south of Chaleur Bay, top. Recent intensive logging leaves telltale pink cutouts, while similar light green patches are cut-over areas beginning to regenerate. The medium green colouring at top left, surrounded by the lighter green of new growth, indicates a flourishing native mixedwood forest, while due south of Bathurst, dark green areas designate mature stands of softwoods that will inevitably feed the area's paper mills. The bright red of a massive forest-fire scar, far right, shows that not all of our deforestation is for profit.

The region's physical and cultural geography both form interesting radial patterns focused on the Bathurst town site. The community itself borders on the banks of the Nepisiguit River and surrounds Bathurst harbour. Beyond the magenta-coloured tongues of sand and sediment that shelter the harbour lies the larger Nepisiguit Bay, which in turn gives way to Chaleur Bay. The estuary of the famous Miramichi River, known for its salmon fishing, is seen at bottom right. Forillon National Park protrudes into Gaspé Bay at top right.

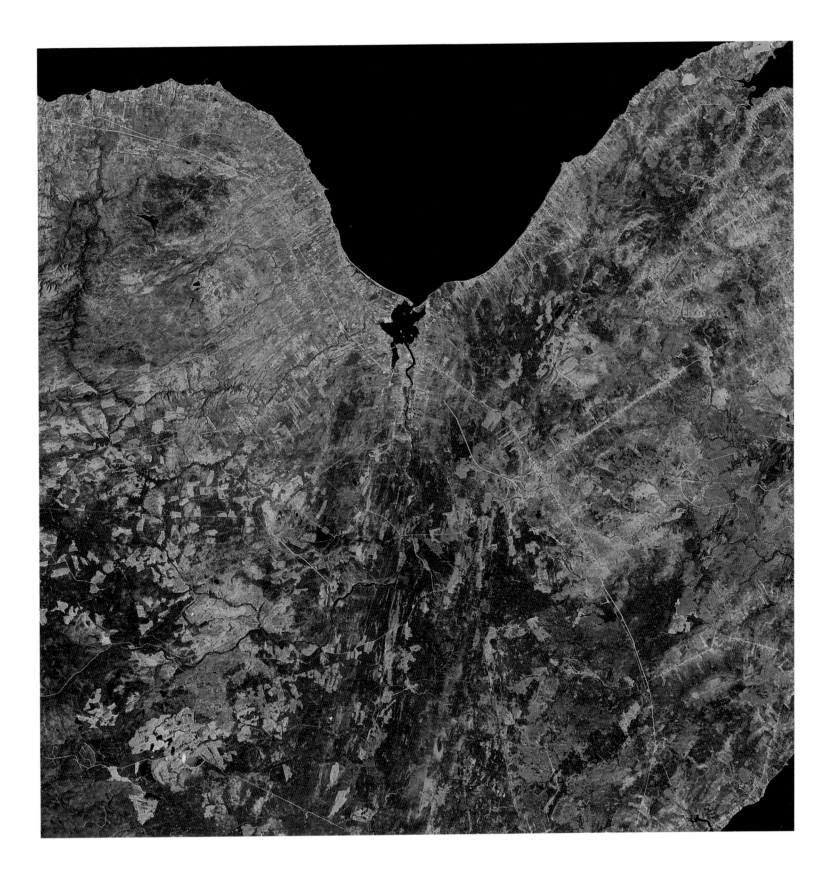

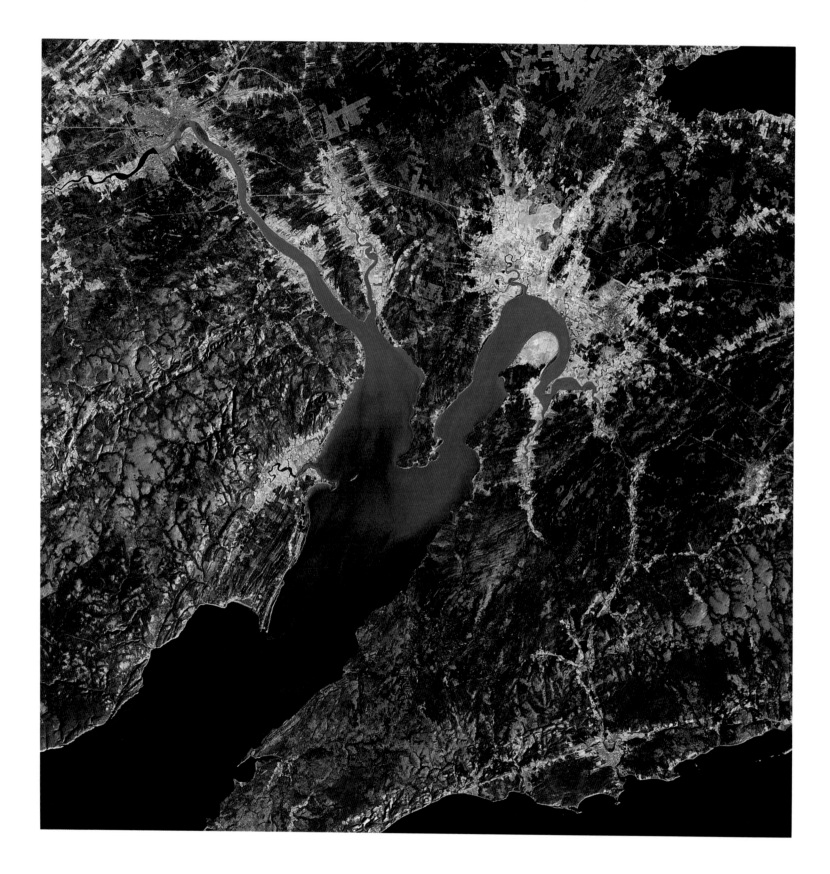

□ □

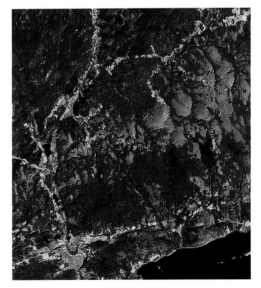

Inundated by the rising seas when glaciers from the last ice age began to melt, the coastline of eastern North America is a continuous series of long estuaries, inlets and bays. Here, powered by the strongest tide in the world, Chignecto Bay, at the head of the Bay of Fundy, takes on a light, milky blue tinge where silt and sediment wash into it from the surrounding uplands of Nova Scotia, right, and New Brunswick, left. The tide, which at its peak can flow at 2,000 times the average rate of the St. Lawrence River, creates the famous tidal bore that attracts tourists to the region. The city of Moncton, top left, is located on the upper reaches of the Petitcodiac River, above Shepody Bay. The U-shaped bay to the northeast is the Cumberland Basin, which brings life to the famous saltwater Tantramar Marsh, on the Chignecto Isthmus. A series of dykes built in the 18th and 19th centuries drained 90 percent of the marsh, whose rich soils show up in pink and yellow. A portion of the Northumberland Strait, separating the mainland from Prince Edward Island, is seen at upper right.

Pinkish brown rocks laid bare by the last glacial advance are evident on both sides of the Chignecto, their surfaces etched by rivers that support marginal forest growth. The most noticeable river is the Hēbert, a traditional native canoe route that connects Chignecto Bay to the Minas Basin, at bottom left. To the east of the Hēbert River lie the bald, rounded tops of the Cobequid Mountains (see detail, right).

□ □

This familiar segment of central Nova Scotia takes in the province's two principal areas of concentrated population settlement and economic vitality: the Annapolis Valley, at upper left, and the city of Halifax, centre right. Famous as a fertile agricultural oasis in an otherwise rocky, wooded province, the Annapolis Valley has small, tightly packed fields, many of which were once part of a long, marshy lowland. Acadian settlers built dykes and began draining the swamps when they established Port-Royal in 1605 (now Annapolis Royal at the southeast end of the valley, just off the image to the left) as the first permanent European settlement north of Florida. By the end of the century, Acadian farms and villages were also thriving around the Minas Basin, top, at the north end of the valley. The British capture of Port-Royal in 1710 marked the beginning of the valley's transition from French to English, a shift that culminated in the expulsion from the province of some 13,000 Acadians in 1755.

The British-French conflict was also responsible for the founding of Halifax, established in 1749 to offset the reversion of Louisbourg (on Cape Breton Island) to France the previous year. The British soon regained control of the region, and Halifax emerged as the area's primary commercial and military port. Today, with about 300,000 people in greater Metropolitan Halifax (including such communities as Dartmouth, Bedford and Sackville), it is the largest urban centre in Atlantic Canada.

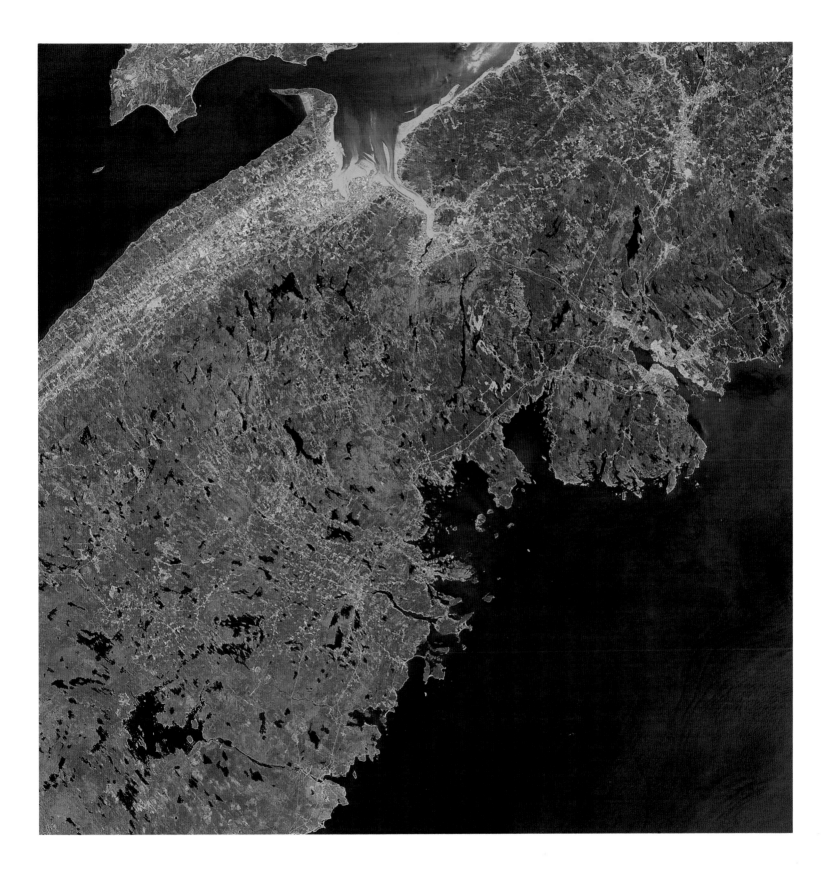

All but the far northeastern tip of Prince Edward Island, Canada's smallest province, can be captured in a single Landsat image. To the north is the Gulf of St. Lawrence, to the south the Northumberland Strait. Someday, a "fixed link" may actually bridge the strait's narrow, warm waters. Until it does, a ferry ride remains the primary means of travel between the island and the north coasts of Nova Scotia, bottom right, and New Brunswick, bottom left, areas that Islanders traditionally lump together with the rest of Canada as part of the mainland.

Even if you knew nothing about Prince Edward Island, it would not be hard to tell from looking at this image that agriculture is an economic mainstay. From the north cape to the east point, the island is a continuous blanket of farmers' fields in yellow, light green and mauve (the latter of the three indicates exposed soil). This false-colour representation unfortunately robs the island of what is undoubtedly its most vivid, poignant symbol: rich, iron-red earth. Small portions of wooded land, in dark green, are found mainly on the island's eastern and western extremes, and the famous north-shore beaches and sand dunes run the entire length of the island.

Prince Edward Island's agricultural pre-dominance is so great that the bulk of the island's 130,000 residents are rural rather than urban dwellers. With a population of just 15,000, Charlottetown is the province's only city of any consequence. Located in the centre of the island in a well-sheltered harbour at the head of Hillsborough Bay, it is the hub of all things urban: government, finance and culture. Summerside, the island's second largest city, with a population of about 7,000, is situated farther west, where the island narrows to its smallest point. Immediately north of Summerside is Malpeque Bay, original home of the famous oysters that now carry its name.

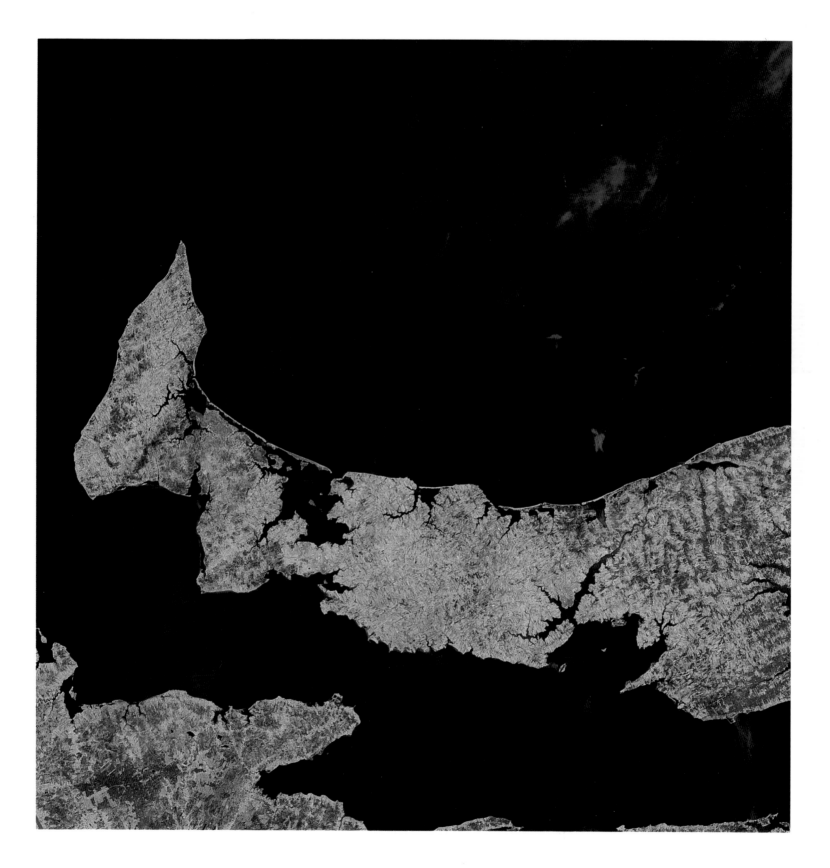

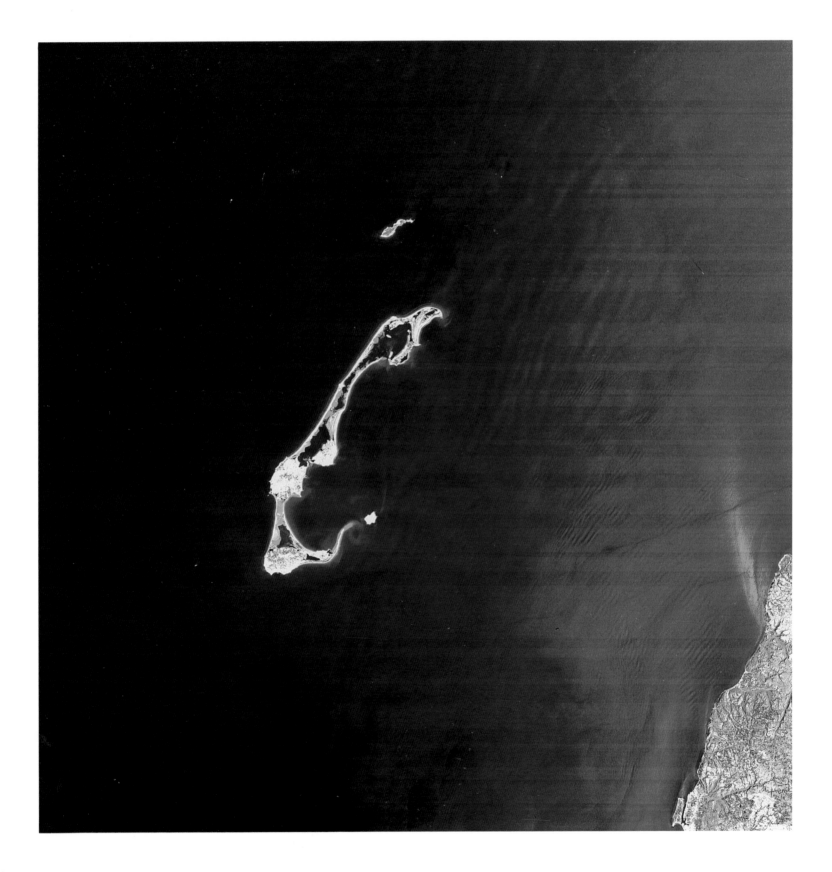

Along most of Canada's Atlantic Coast, the submerged continental shelf extends seaward by as much as several hundred kilometres. Where it does, the waters are seldom more than 200 metres deep. Over most of the legendary fishing banks, 100 metres is more the norm, and in a very few places, the shelf even pokes through to the surface. One such rare spot is Îles de la Madeleine, an isolated string of tiny islands, sandbars and lagoons in the southern Gulf of St. Lawrence. Although a part of Québec, the closest these remote outliers come to the rest of Canada is a 100-kilometre stretch of water between their shores and Cape Breton Island, bottom right. In practical terms, the nearest thing to a physical link is a five-hour ferry ride from Souris, Prince Edward Island, to Cap-aux-Meules, one of several small communities on the protected eastern shore of Île du Cap aux Meules, the cluster's central member.

Îles de la Madeleine's presence was much less tenuous 8,000 to 10,000 years ago, when glaciers still covered large parts of the northern hemisphere, ocean levels were significantly lower than today and substantially more of the continental shelf was exposed. As a result, these islands were much larger and fully joined. Firm land connections also existed between present-day Prince Edward Island, Cape Breton Island and peninsular Nova Scotia. On the other hand, today's situation looks good by tomorrow's prospects, in which predictions of a global warming and a corresponding rise in sea level in the next century suggest that even more of the Îles de la Madeleine may disappear beneath the waves.

Sixteenth-century Portuguese fishermen called it Tierra de Los Bretones; to the French who first settled its steep, rocky inlets and bays in the 17th century, it was Île Royale; but it was not until 1762, when the British wrested control of this and the rest of what was to become Canada from France in the Seven Years' War, that Cape Breton arrived at its present English title. Besides a name change, the British arrival also spelled the end for the French fortress at Louisbourg. Located on the southeastern shore, Louisbourg was the island's first major settlement and Acadia's last great military and commercial stronghold. Al-

though British occupation eventually produced much larger cities, such as Sydney and Glace Bay, which would thrive for another 150 years as coal-mining and steel-making centres, the destruction of the French fortress represents the first in a long line of setbacks that have since left Cape Breton one of Canada's most isolated and economically depressed regions.

Today, Sydney, Glace Bay and New Waterford (blue clusters on the lower northeastern shore) remain as the island's largest urban centres. Cape Breton's greatest assets, though, are probably its steep ocean cliffs, rugged interior highlands and

wandering, intricate coastline. Together, they make the island one of the most picturesque and popular destinations for Maritime travellers. These features achieve some of their greatest splendour on the island's large northern peninsula, site of the famous Cabot Trail and Cape Breton Highlands National Park. The park's southern boundary corresponds roughly with the break between the blue and green area (bare rock, trees and other vegetation) and the patchwork of bright yellow and mauve (land recently cleared for logging). The large expanse of water in the centre of the island is Bras d'Or Lake.

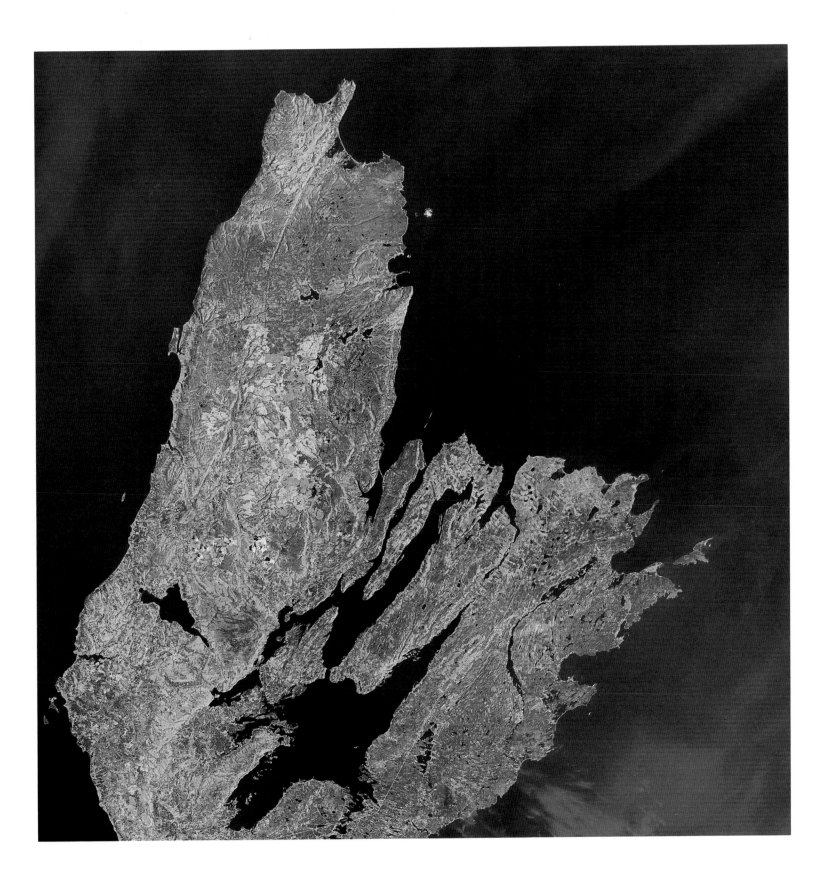

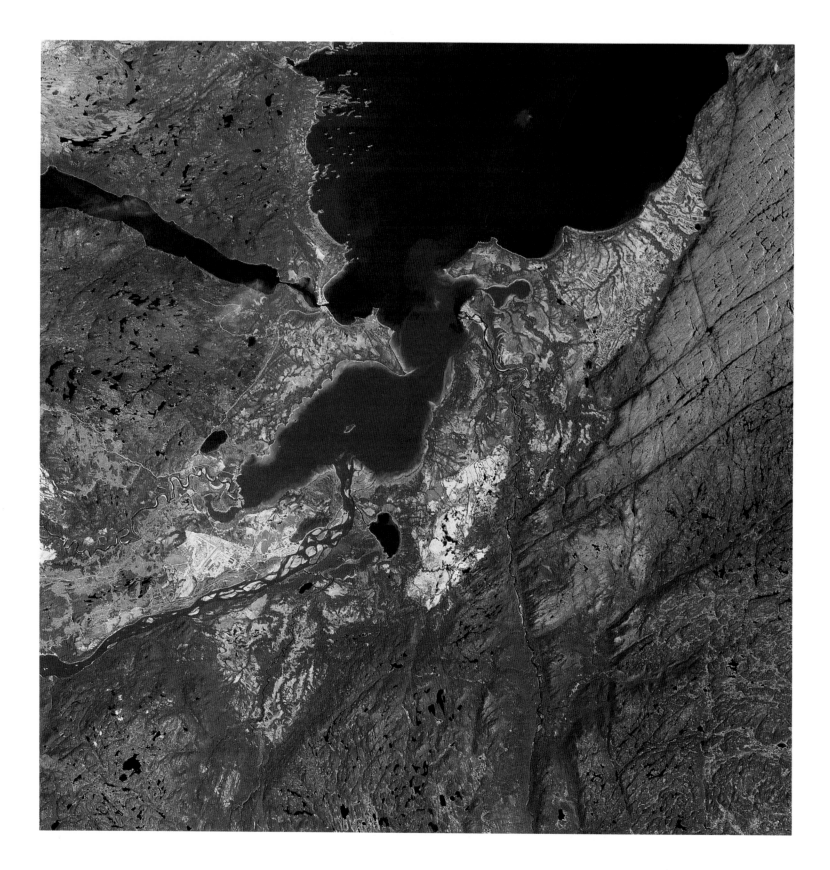

Canada's twenty-third longest river is the Churchill. The country's eighteenth largest lake is Lake Melville. The two meet at a remote place in central Labrador called Happy Valley-Goose Bay, the small, turbid inlet at centre. The town site shows up clearly as a blue and white network of buildings and streets to the left. A larger blotch to the west indicates the town's military base and air-force runways, which dominate the area's politics and economy.

Once the allied air force's largest refuelling point, Happy Valley-Goose Bay was the key to Britain's air superiority during World War II. But its more recent function as a training centre from which European fighter pilots fly simulated low-level bombing missions over the surrounding territory has been its most controversial. Native people living in the region today claim that the missions flown over their territory are destroying their way of life and disrupting the area's wildlife. Recently, native groups began blocking the airport's runways as a means of making themselves heard.

The region's ancient geologic history is told by the bare expanse of Canadian Shield to the upper right. The speckled yellow and brown terrain at the base of the lake is a sandy muskeg fashioned from sediment discharged by the Churchill River. Sandbars also dot the river's mouth, while the huge green scar of a recent forest fire covers much of the land between Happy Valley-Goose Bay and long, narrow Grand Lake, top left.

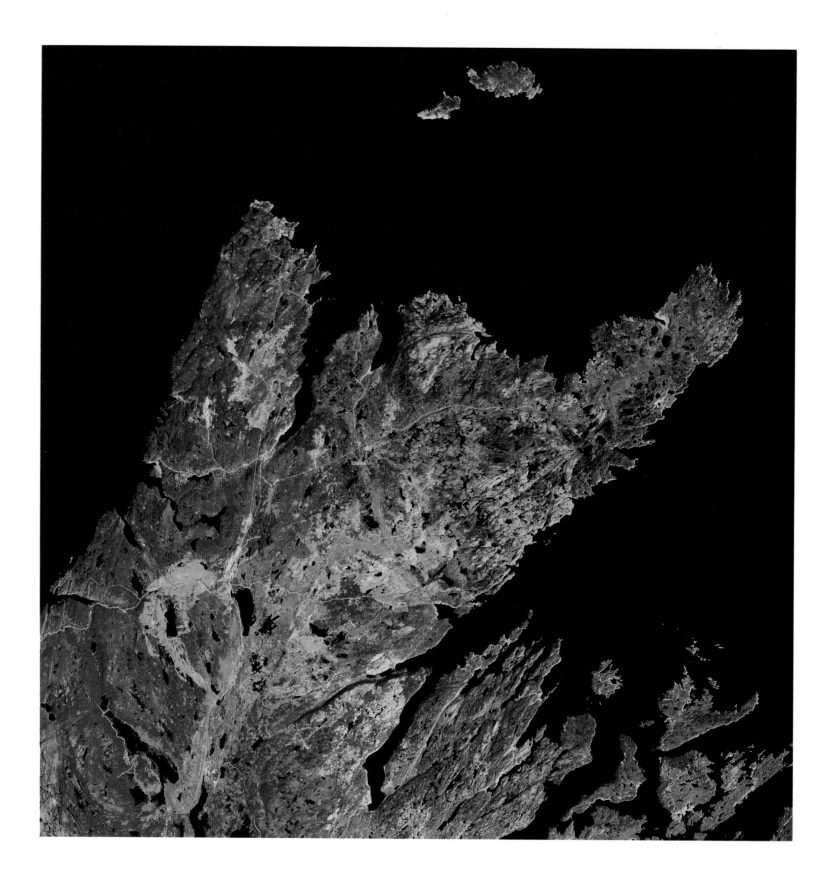

The northern coast of central Newfoundland juts into the Labrador Sea, its rugged shoreline bristling with dozens of bays and coves. The waters of Notre Dame Bay, the large bay to the east, are rich in cod, capelin and lobster, fuelling a commercial fishery that operates out of dozens of small ports with colourful names like Lushes Bight, Nickey's Nose Cove, Nippers Harbour and Snooks Arm. Inland, the chief business is forestry; splotches of green indicate forest-fire damage, while orange shows the extent of current logging operations. Patches of brown indicate areas covered with coniferous forest; barren rock outcrops are grey. The most westerly of the three bays at the top of the image is Baie Verte, a long, narrow cove that is remarkable for the blue scar on its western shore—evidence of massive asbestos and copper-mining operations (see detail, right). Farther to the west, beyond the open waters of White Bay, a narrow portion of Newfoundland's mountainous Great Northern Peninsula is visible.

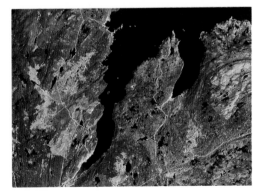

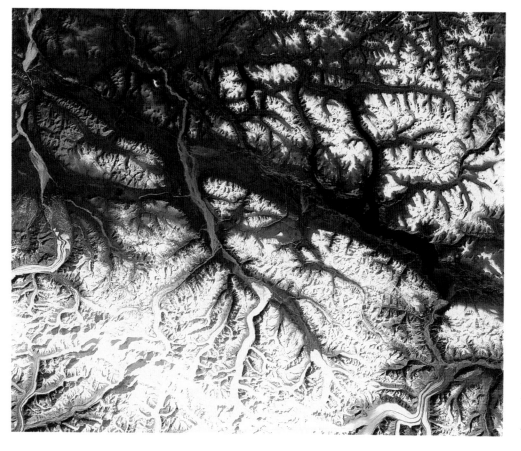

The towering St. Elias Mountains rise steeply along the Pacific Coast, forming a barrier to the interior that extends from southern Alaska and extreme southwestern Yukon to northern British Columbia. Packed into the Canadian portion of this small range are the country's 22 highest mountains. The tallest of these, Mount Logan (5,951 metres), is among the peaks casting a jagged line of blue-grey shadows just to the left and slightly above the centre of the image (right).

The Alaska/Yukon border runs horizontally across this same image just slightly to the south. The huge lobe of blue-white ice oozing out of the mountains toward the coast is the Malaspina Glacier. Yakutat Bay and the community of Yakutat, Alaska (including its airstrip), are visible to its right. Everything to the north of the border is contained within the boundaries of Kluane National Park. Kluane Lake is the predominant feature (left), its long, narrow outline conforming to the contours of the deep trench that divides the St. Elias Mountains from those of the interior. The thin grey line running the length of the trench is a stretch of the Alaska Highway.

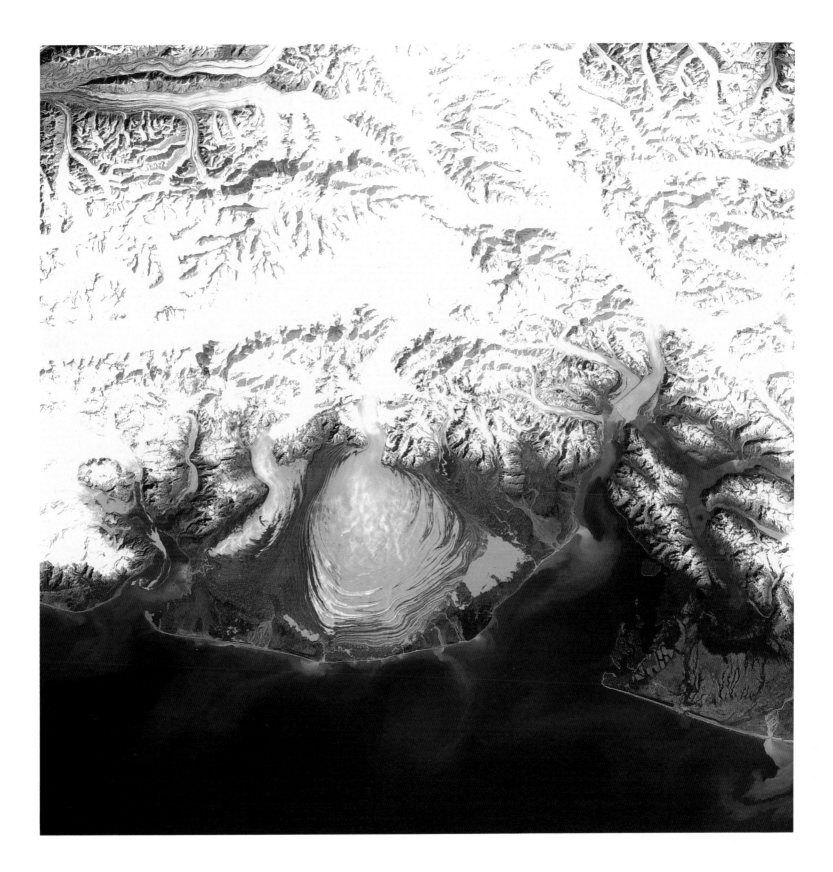

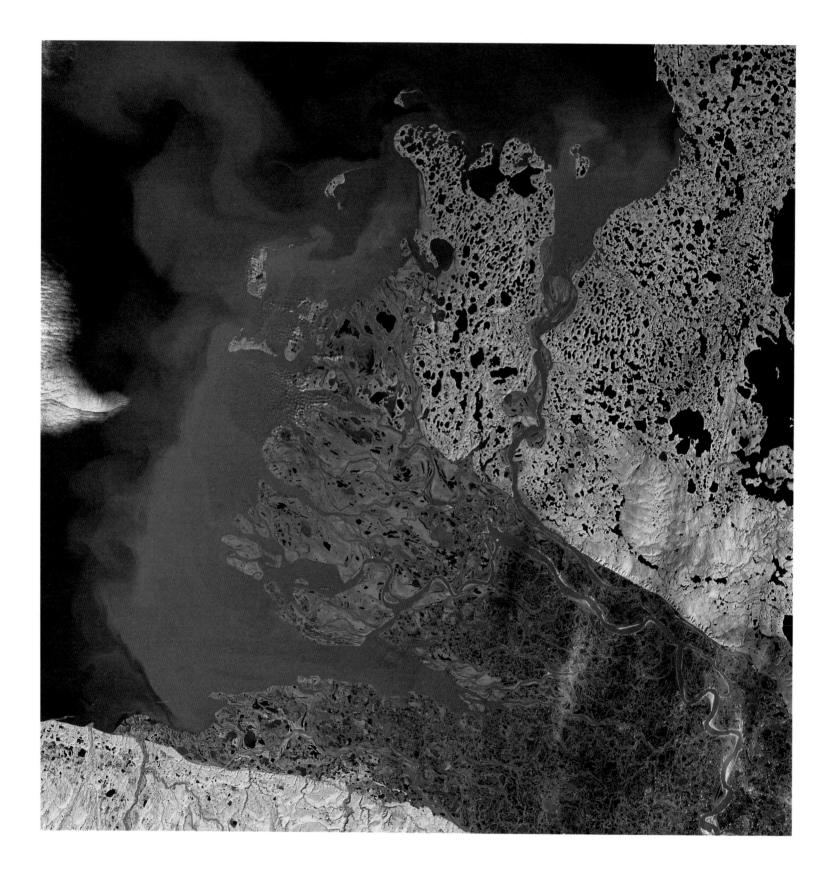

After flowing more than 4,200 kilometres from its source at Great Slave Lake, the Mackenzie River empties into the Beaufort Sea. As Canada's longest river, the Mackenzie reaches the Arctic heavily laden with silt and suspended sediments that settle out at its mouth. Over thousands of years, the sediments have built up to form the huge delta seen here. Composed of hundreds of low alluvial islands and a maze of braided channels, the delta (left) continues to expand gradually seaward even today.

The lighter-coloured lands to the right of the delta are Richards Island and Tuktoyaktuk Peninsula. (The site of Tuktoyaktuk, the area's main settlement and an important transportation base for local oil- and gas-exploration activities, is barely discernible on the shore of Kugmallit Bay, midway up the coast.) This hummocky moraine, pitted with countless ponds and lakes, was deposited by glaciers more than 10,000 years ago. Now, the only ice that affects the region comes from the sea. It dominates the more recent image (right), even though it was taken in late June 1986 by Landsat 5, with the area basking in 24-hour daylight. By comparison, the earlier ice-free image was obtained in mid-September 1973 by Landsat 1.

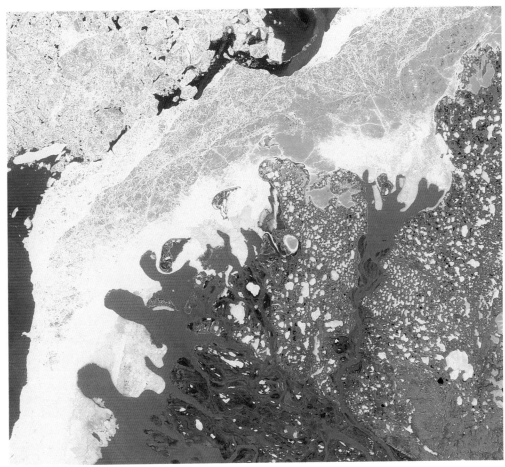

When people speak of oil and the Mackenzie River, they are usually referring to the Mackenzie River Delta and offshore drilling in the Beaufort Sea. Yet for years, oil and the Mackenzie have also come together many kilometres inland, at a place called Norman Wells. In this image, the small community is barely visible at the extreme right as a small grey-brown clearing with an adjoining airstrip on the Mackenzie's eastern bank. Slightly more detectable are the small white dots in the Mackenzie's frozen light blue channel—the Norman Wells oil rigs.

Located just to the west of southern Great Bear Lake, the oil fields at Norman Wells have less in common with those in the Beaufort than with others farther south in the Alberta "oil patch." This is because both northern Alberta and the upper Mackenzie River Valley are underlain by the same sedimentary geology that makes up the foundation of the Great Plains all the way south to Texas.

This image also provides a good perspective on the overall character of the Mackenzie River Valley and the edge of the adjoining Mackenzie Mountains, bottom. Like most of the Arctic, this valley receives little precipitation. As a result, many of the surface features are the same as those typically found in warmer deserts farther south. Among them are braided river channels and several alluvial fans. The latter are fan-shaped deposits of sand and gravel dropped from fast-flowing small rivers at the edge of the mountains where, after leaving the steep gradient of the mountains for the flatter valley floor, they slow down, spread out and lose much of their carrying capacity.

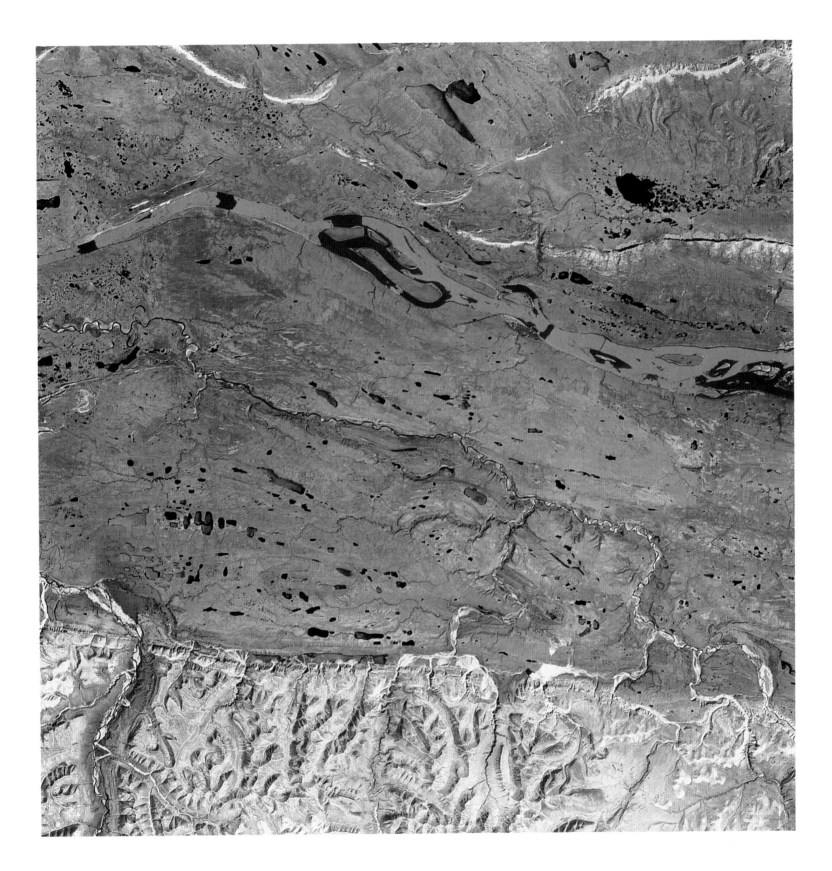

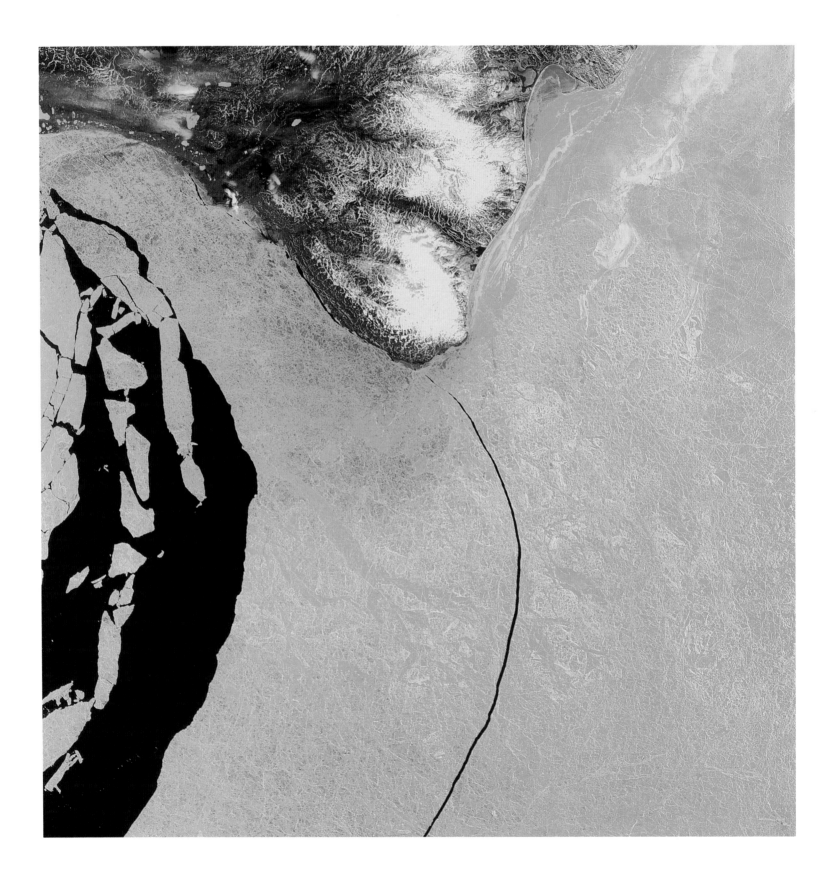

Spring breakup opens a crack more than 100 kilometres long in the pack ice off Cape Lambton, at the southern tip of Banks Island in the Arctic. Farther west, ice floes that split from the pack in earlier days drift lazily through the inky black waters of Amundsen Gulf toward the Beaufort Sea. Although it is now early June, the only other areas of open running water are in Banks Island's larger river valleys and along parts of its rocky shoreline.

Ironically, although it is now covered with snow and ice for most of the year, much of Banks Island was never touched by the Pleistocene glaciers that once covered the rest of Canada. It is a modern-day paradox that parts of this cold, remote island are now teeming with life: musk ox, arctic foxes, lemmings, arctic hares, numerous birds and caribou. In these important areas, the arrival of summer and 24-hour daylight and the thawing of rivers and streams trigger

short, explosive cycles of intense biological activity. Egg River (just slightly out of the image to the top left) is one such place. Here, thousands of snow geese congregate to lay their eggs, moult and raise their young. The new birds are airborne in remarkably short order. Only six or eight weeks after arriving, the flock will again depart, winging its way out over the gulf toward wintering grounds thousands of kilometres to the south.

A permanent, narrow ice cap divides Axel Heiberg Island's bald, weathered terrain into a western and an eastern flank. Short, truncated glaciers extend partway down each slope, but the lack of annual snowfall in this high-Arctic desert starves the narrow lobes before they can reach the sea. The result is a stark, barren coastline, its rock-and-gravel surface covered only by a thin, incomplete veneer of rusty brown mosses and lichens. Although this is a false-colour image, the deep reticulated channels and exposed rock make it easy to understand how Arctic traveller and author Barry Lopez could liken this northern landscape to the mountains of Arizona and the colourful brown, yellow and tan canyons of the Colorado Plateau.

Locked in the frozen embrace of Ellesmere Island, its larger adjacent eastern counterpart, Axel Heiberg is situated on the northern edge of Canada's Arctic Archipelago. Between its icy shores and the north pole, there is only the Arctic Ocean.

The pack ice visible on the left edge of this image is floating in a part of Sverdrup Channel, named after Otto Sverdrup, a Norwegian explorer who was one of the first to visit Axel Heiberg Island. To the right are several fiords that lead into Eureka Sound. From there, it is just a short hop across the waterway to Eureka, a small, remote settlement on the western shore of Ellesmere Island. Only Alert, at the tip of Ellesmere Island, is a more northerly community.

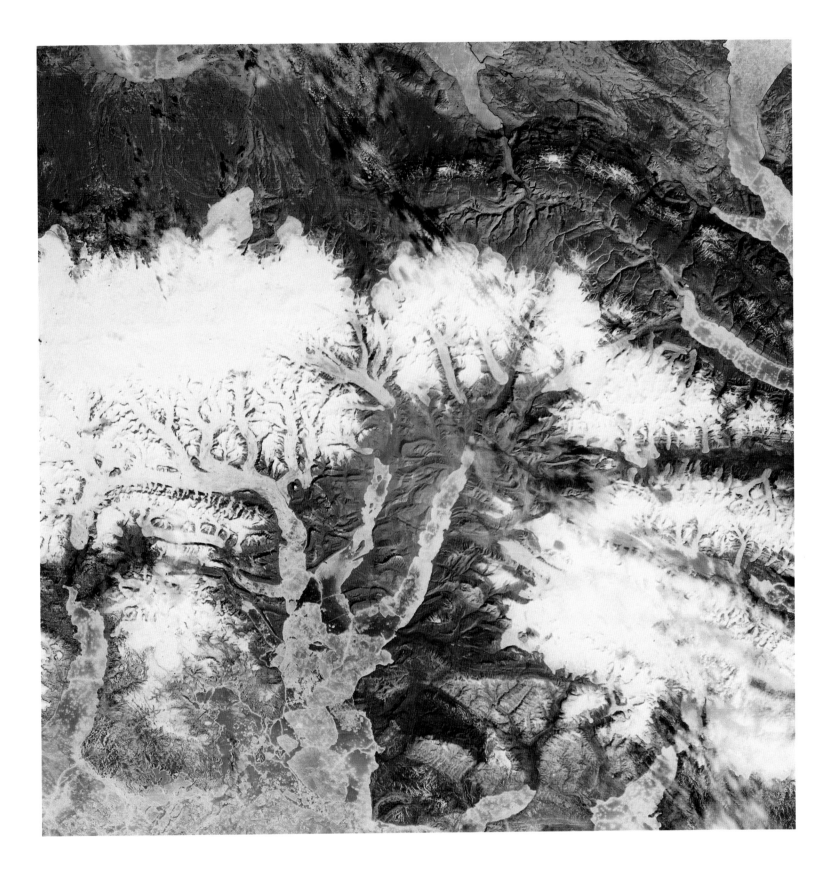

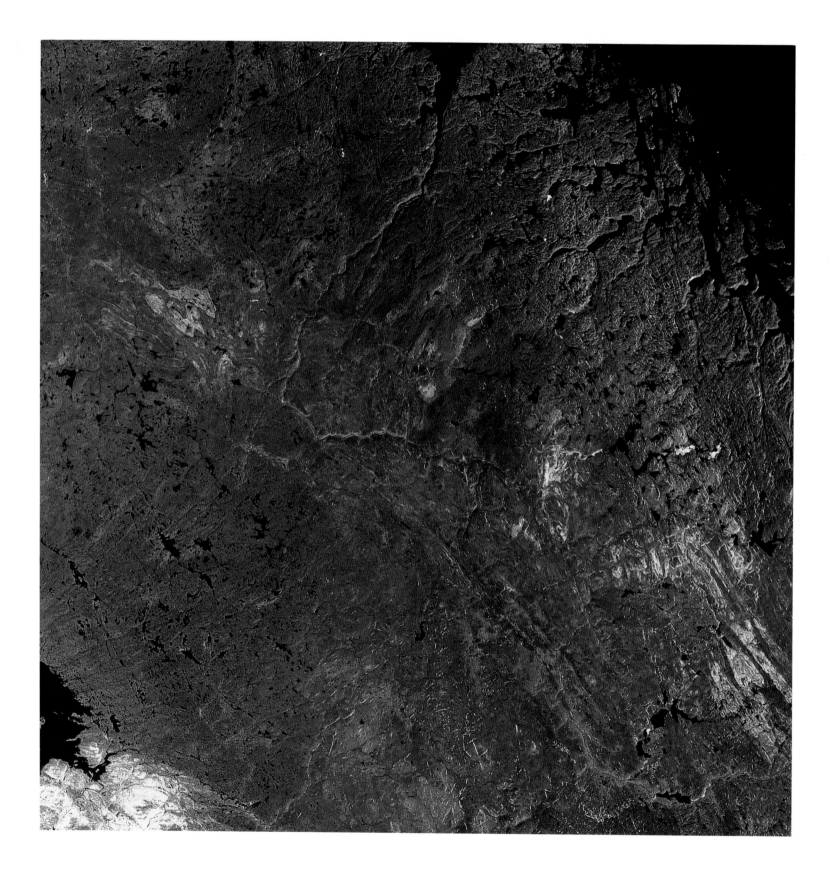

At more than 500,000 square kilometres, Baffin Island is not only Canada's largest island but the fifth largest in the world. Named for English navigator and explorer William Baffin, it is home to approximately one-quarter of Canada's Inuit population. The area pictured here is known as the Great Plain of the Koukdjuak, part of the island's vast south-central interior plateau. Located at about the same latitude as Great Bear Lake, just south of the Arctic Circle, it is a rocky plain riddled with numerous lakes, ponds, rivers and streams. In this early-September image, it is virtually free of snow and ice. While confined mainly to river valleys and coastal lowlands, the patches of red and pale green indicate a diverse assortment of vegetation, including dwarf birch, alder, willow and blueberry, and a variety of lichens and mosses.

The large river valley visible at centre as it bends and twists to the north holds the McKeand River. It empties into Irvine Inlet, which in turn is part of Cumberland Sound, upper right, where several Inuit communities, including Pangnirtung, are situated. The body of water in the far southwest is a corner of Amadjuak Lake. To the southeast, just out of the image, lie the innermost waters of Frobisher Bay.

□ □

Rivers of ice and snow pour forth from the year-round ice cap crowning the central heights of Bylot Island. In this arid expanse of the eastern Arctic, there is only enough snow and ice to sustain a few of the glaciers all the way to the water's edge. Those that do reach the shore carve out deep, U-shaped valleys on their way, before eventually breaking off into tiny floes and larger bergs like those visible in Lancaster Sound to the north. Where the rest of them come up short, the island's rocky plateaus and coastline are exposed in all their bare glory, since the only vegetation growing in this frozen desert consists mainly of lichens and mosses. In several places, melting ice fills clusters of tiny ponds and gives life to small streams meandering to the coast.

Named after Robert Bylot, the English captain who sailed to the area with pilot William Baffin in 1615 and again in 1616 in a successful search for the opening to the Northwest Passage, the island stands like a sentry at the eastern entrance to that much-sought-after channel, above. To the south, the land across Navy Board Inlet, left, Eclipse Sound, below, and Pond Inlet, to the right, marks the northern edge of Baffin Island, the much larger landmass named after Bylot's co-explorer. The community of Pond Inlet is just visible on the shore of Baffin Island, right, where the stream draining the dark blue lake empties into the sea (see detail, left).

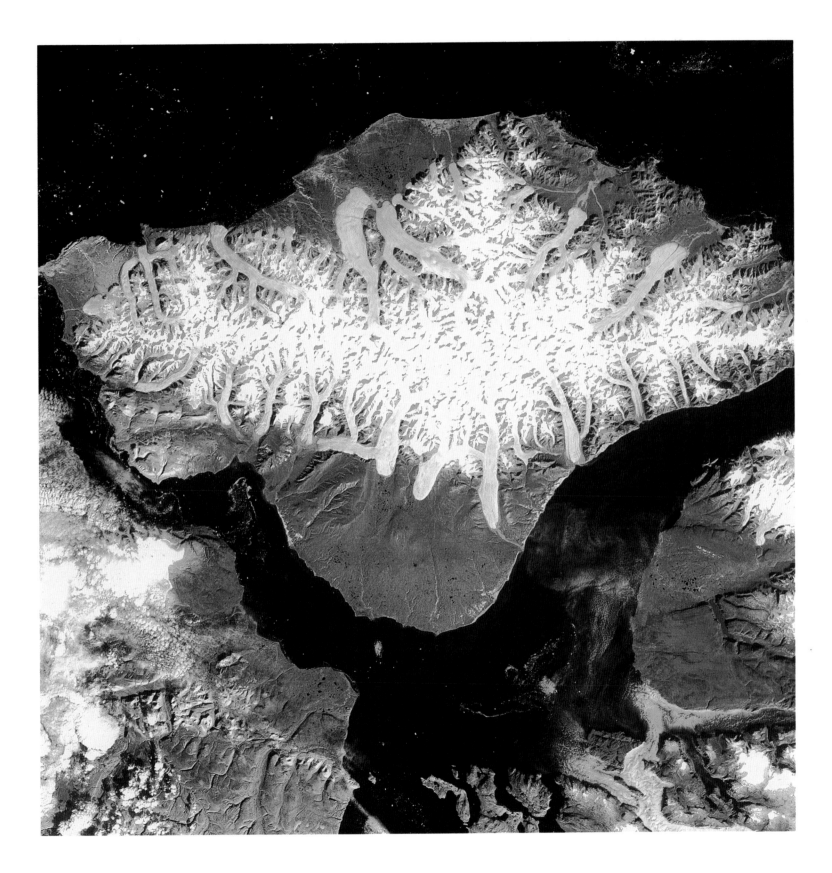

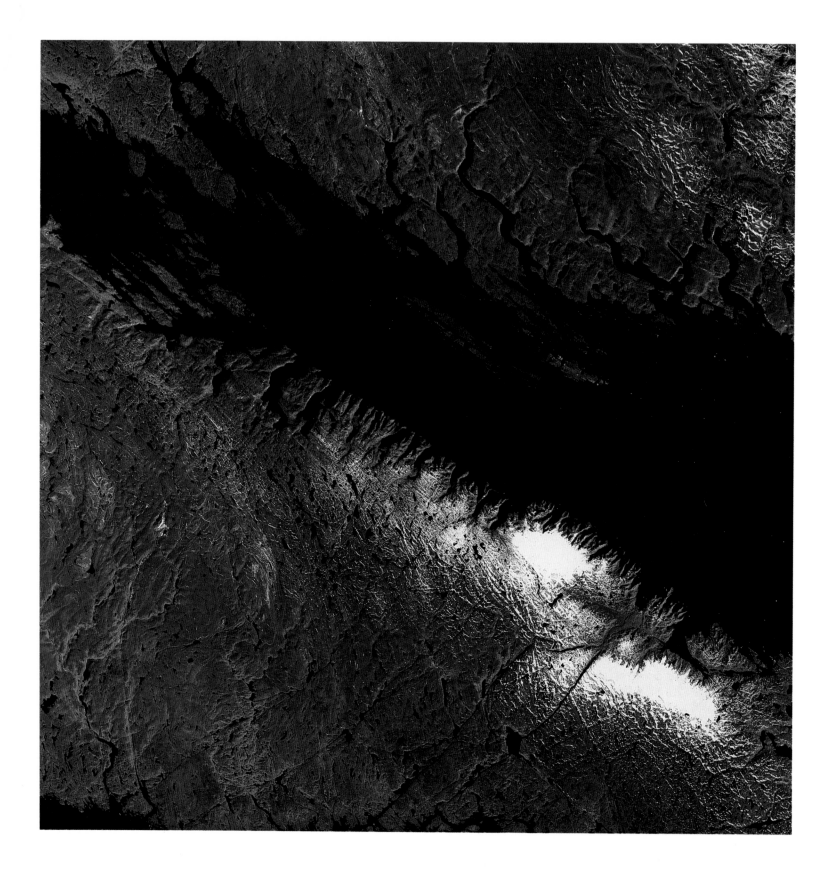

Extending some 300 kilometres inland from the southeast coast of Baffin Island, Frobisher Bay was one of the first waterways in the eastern Arctic to be mistaken for an entrance to the Northwest Passage by European explorers. In 1576, on the first of three expeditions he would make to the bay that now bears his name, England's Martin Frobisher spent 15 days exploring both inner coasts before returning home with the belief that one coast was part of Asia and the other part of North America.

Among Frobisher's patrons was Queen Elizabeth I, who went so far as to give the captain a gold neck chain before his third and final trip. By that time, Queen Elizabeth had taken it upon herself to name the large peninsula that forms the bay's south shore. She called it Meta Incognita Peninsula, usually translated as "unknown edge" or "mysterious land."

By the time of Frobisher's voyage, the bay, Baffin Island and most of the eastern Arctic had already been populated for several thousand years—first by a succession of palaeo-Eskimo peoples (the pre-Dorset and Dorset) originally from Alaska, who were then displaced about a thousand years ago by other Alaskan neo-Eskimo groups (the Thule), from whom the present native Inuit inhabitants descend. Today, the town of Frobisher Bay (off the image to the northwest at the head of the bay) ranks as one of the largest Inuit communities in the eastern Arctic.

Usually covered in snow and ice, the bay and the surrounding terrain are caught in this mid-August image with only a small amount of snow cover and just the tiniest of ice floes dotting the water. The dark grey over much of the land indicates bare rock. The only vegetation—mainly lichens, herbs and grasses—shows up in the form of a pale red frosting limited to valleys and sheltered inland regions.

PHOTO CREDITS

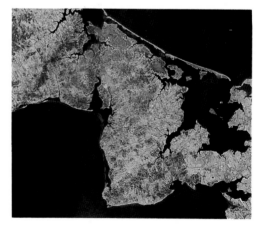